HANLEY
THEN & NOW
IN COLOUR

JOHN S. BOOTH

Best wishes

J S Booth

The
History
Press

First published in 2012

The History Press
The Mill, Brimscombe Port
Stroud, Gloucestershire, GL5 2QG
www.thehistorypress.co.uk

ISBN 978 0 7524 7006 1

Typesetting and origination by The History Press
Printed in India.

CONTENTS

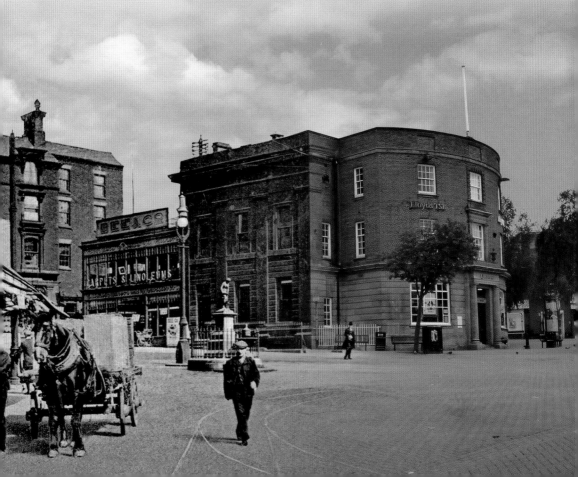

ACKNOWLEDGEMENTS

Welcome to my third book about Hanley, in which I hope to show some of the many changes that have taken place over the past 100 years. All but one of the old photographs come from my own collection of early twentieth-century postcards. The picture on page 70 comes from the archives of Harrison & Son (Hanley) Ltd.

The 2011 pictures were mostly taken during visits to Hanley on a Sunday morning: Hanley is busy throughout the week, with lots of people and many street stalls, so the scenes would have been obscured on a weekday.

Much of the information in this book has been drawn from the many directories of Stoke-on-Trent; I also drew on Mr A. Huntbach's volume of 1910, *Hanley, Stoke-on-Trent: Thirteenth to Twentieth Century* and on the archives of the *Staffordshire Advertiser*.

Thank you to the wonderful staff in the Stoke-on-Trent City Archives for their help. My sincere thanks also to Mrs Elaine Titley, who provided the 2011 picture of Bethesda Chapel and helped to improve the quality of the black and white pictures for publication, and to Victoria Fenton for proof-reading this book.

Last but not least, I would like to thank my cousin Gill for permission to use a family picture, and to my friend Fred Hughes and my wife Jean for all their support.

FOREWORD

Hard on the back of his previous two books on Hanley, the author, John Booth, has in this new volume delivered a fresh approach to visual local history by taking readers to a place where they can reflect on the urban and social changes that have evolved over the best part of a century. And what an astonishing transformation there has been.

John's personal collection of picture postcards forms the base of this history of the Potteries' built environment. Uniquely he has matched many rare views of Hanley's long-forgotten highways and byways with his own contemporary side-by-side pictures thereby not only leading us on a nostalgic and magical journey down memory lane, but also providing future researchers and students with a valuable resource of post industrial regeneration. Thanks for the memories John.

Fred Hughes, writer and social historian, 2012

INTRODUCTION

From the two small farm hamlets known in the seventeenth century as Hanley Upper Green and Hanley Lower Green, Hanley grew and grew over the next 300 years, becoming the largest of the six towns that, in 1910, formed the city of Stoke-on-Trent.

Due to its central locality, Hanley became the centre of commerce and was the first of the six towns to become a County Borough, in 1857. Today it is the official city centre. Many of the gazetteers published in Victorian days informed the traveller of the wide, well-paved streets and many fine buildings that could be found, and described Hanley as 'the metropolis of the Potteries'. Hanley had – and still has – some beautiful architectural buildings: you only have to look above the present-day shop-window level. The oldest buildings in Hanley are churches and inns, with many commercial buildings being progressively improved or rebuilt during the reign of Queen Victoria and later.

It seems that Hanley has never been allowed to settle, always being pushed to improve itself. The first piped water into shops, factories and houses began in around 1820; the first gasworks were built in 1825, and the first electricity company was formed about 1894, with electric street lights being turned on shortly after. By the mid 1800s Hanley had its own police force and fire brigade.

There are many early twentieth-century pictures showing Hanley covered in dense black smoke emitted from the pottery ovens. It seemed that not a day went by that a pottery close to the centre of Hanley was not belching black smoke from its bottle ovens. The Clean Air Act of 1956 put a stop to this, and all the pottery manufacturers changed to tunnel kilns heated by gas or electricity.

In yesteryear, there were many dwelling houses in Hanley and many shop owners lived above their premises. Today there are very few places to live in the centre of Hanley. Since the millennium, Hanley has been transformed again: streets have been pedestrianised, trees planted, and colourful flower beds and hanging baskets scattered around the town. Hanley has green areas to sit in, like the Bethesda Churchyard garden and around the Potteries Museum and Art Gallery, and there are many places in Market Square in which to sit and watch the world go by.

In *Hanley Then & Now* you will see how Hanley has changed to become a modern twenty-first century city centre. The changes to Hanley over the years have gone ahead, even though many local people think they should not have happened. The 1960s and 1970s saw many of Hanley's beautiful old buildings demolished, with new 'modern' replacements. Is this a good thing? Only the future will know.

MARKET DAY

IMAGINE STANDING IN Upper Market Square when the picture below was taken (c.1925) and looking down Market Square towards Lamb Street, with the large Market Hall on the right. The smell of fresh produce in the air, mixed with the odour of cigarette smoke. The smell of soot from the bottle ovens of Weatherby's and Bishop and Stonier, which would be pouring smoke over the square and making the whole area dark. There would be the occasional clatter and

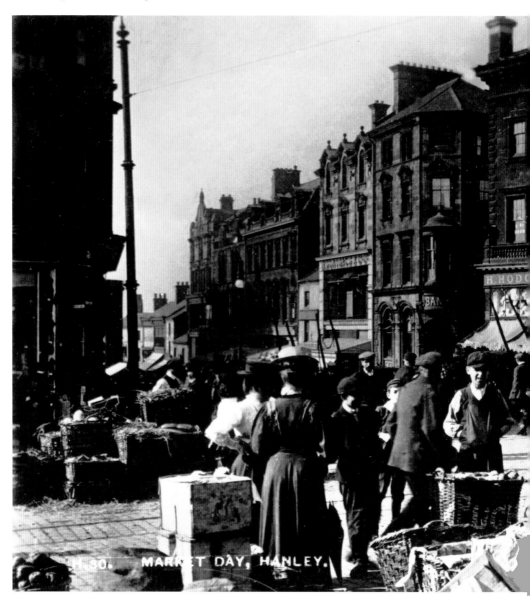

H. 90. MARKET DAY, HANLEY.

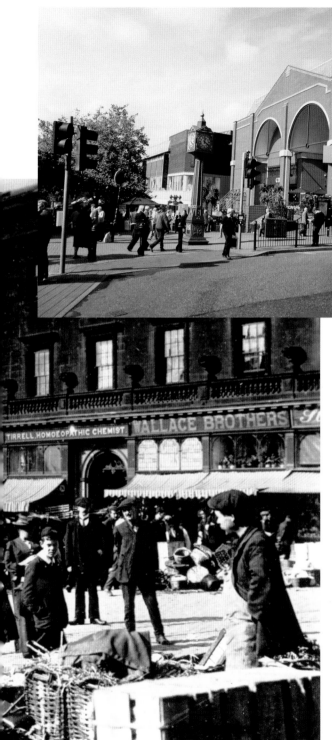

clang as a tram passed and the constant sound of traders shouting out their wares. Look above the street level to see some striking Victorian buildings.

MARKET SQUARE TODAY has little in common with the Market Square of before First World War. There are still some street traders, but few now call the passing public to look at their wares – and none bring the produce on a horse and cart. Market Square today is a smaller paved area for public use. There are mature trees and a couple of small flower gardens, plus lots of hanging baskets all year round. Above all the air is clean, with just the occasional smell from street food stalls. To complete the picture, the old Market Hall has been replaced by a modern shopping centre, but a few of the Victorian buildings still remain.

MARKET SQUARE LOOKING TOWARDS PICCADILLY

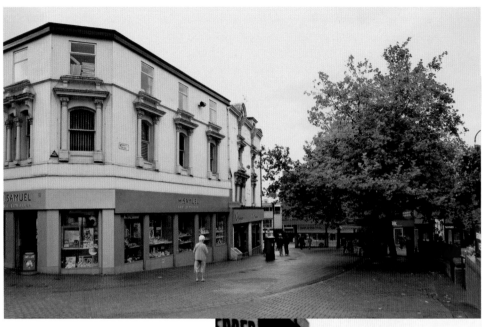

MARKET SQUARE ON a quiet day (right). The shop in the centre of the picture is Henry Pidduck & Sons Ltd, a jeweller's shop of some distinction. Henry Pidduck was born in 1813 in Shrewsbury and became apprenticed to Thomas Joyce, a clockmaker in nearby Whitchurch, in 1827. By 1833 he was considered a master clockmaker. He moved to Hanley, and opened his first shop in 1841; he and his family lived above the shop. Henry Pidduck was the mayor of the Borough of Hanley in 1864 and a prominent local businessman. Pidduck's were commissioned to make the Hales Trophy in 1935, better known as the Blue Riband Trophy and donated to the

fastest passenger-liner crossing the Atlantic Ocean in regular service. The trophy was often on display in Pidduck's window.

TAKEN ON A Sunday, the modern photograph of Market Square shows the smaller paved public area with trees and flower beds. To the left is the building on the left of the old picture; only the ground-floor shop-fronts have changed. At the bottom of Market Square is a new shopping precinct, complete with moving staircases and large display windows, replacing all the old buildings. The jewellery shop of Henry Pidduck & Sons Ltd closed during the 1960s but the company still retain a shop in Southport. During the week this area usually has flower stalls and a children's roundabout.

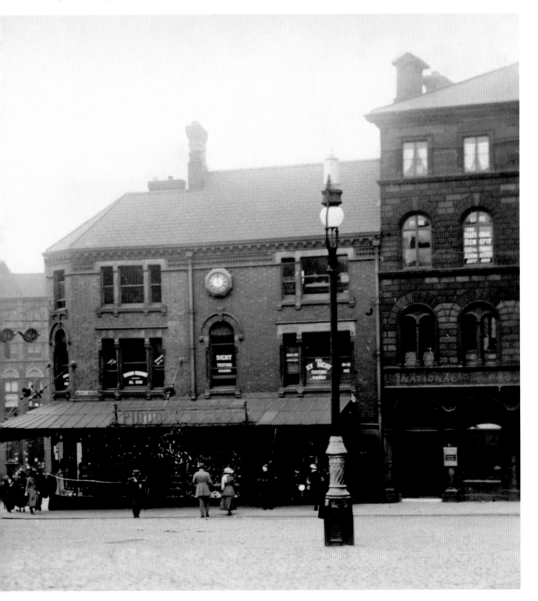

MARKET SQUARE
LOOKING TOWARDS
THE ANGEL HOTEL

MARKET SQUARE IN 1912, looking towards Upper Market Square and High Street (below). The large building in the background is the Angel Hotel, and beside it, to the right, The Grapes public

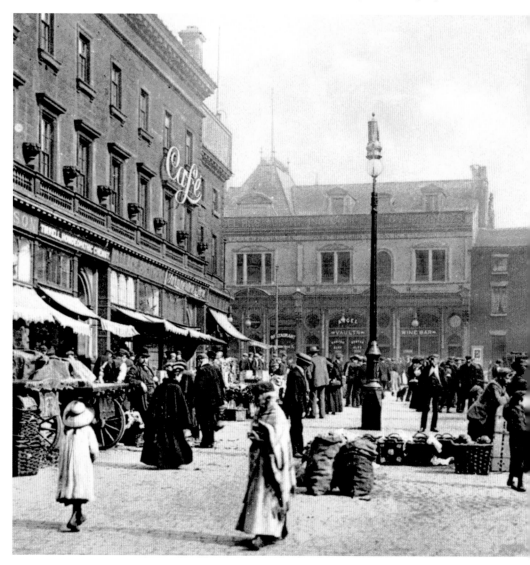

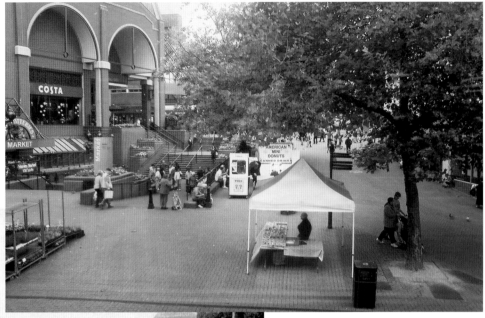

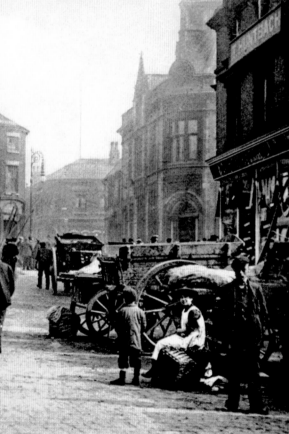

house can be seen. The Angel Hotel and restaurant was a popular meeting place on market days, and many business deals were carried out over a meal and a drink. To the left is the Market Hall with outside stalls in the front. On the right of the picture, Market Street can be seen: The Grapes on one corner and Manchester and Liverpool District Bank on the other corner, forming the beginning of Upper Market Square.

EARLY IN THE morning on a normal weekday in Market Square (above). Street stalls are being set up, as they have been for over 200 years. To the left, the old Market Hall has gone, replaced by the Potteries Shopping Centre, which has a large underground Market Hall below. The entrance to the large Market Hall is on the left of this picture. In the distance can be seen a remaining part of the old Angel Hotel, though the rest of the buildings have been replaced with modern shops and offices.

MARKET SQUARE LOOKING TOWARDS HIGH STREET

A QUIET DAY in Upper Market Square, with Sherwin's music shop on the left and the Angel Hotel and The Grapes on the right of this photograph from around 1920, below. Tramlines run up the

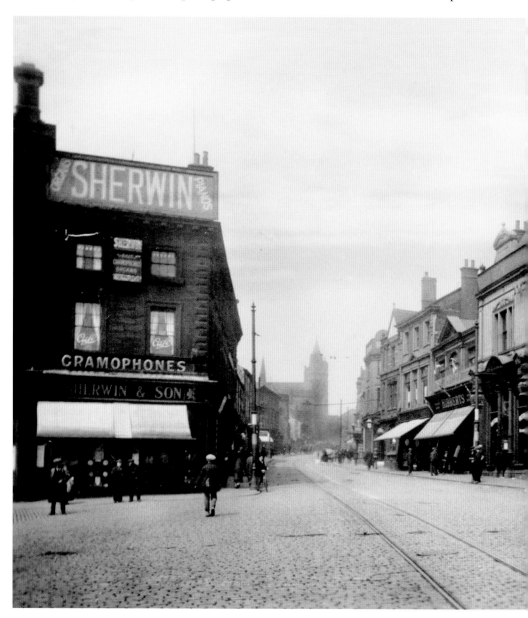

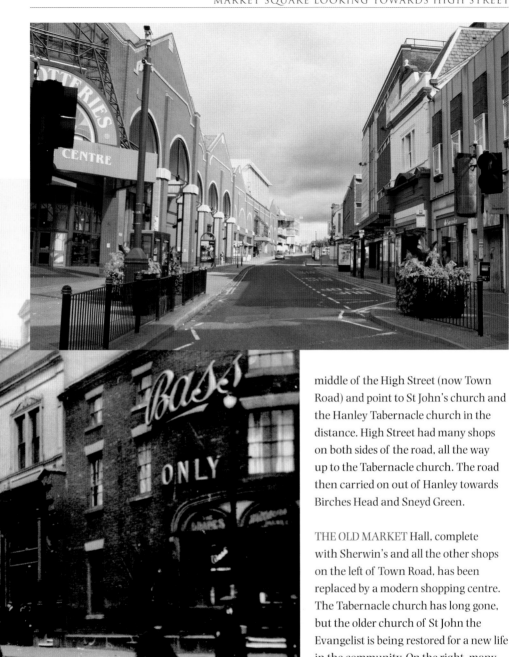

middle of the High Street (now Town Road) and point to St John's church and the Hanley Tabernacle church in the distance. High Street had many shops on both sides of the road, all the way up to the Tabernacle church. The road then carried on out of Hanley towards Birches Head and Sneyd Green.

THE OLD MARKET Hall, complete with Sherwin's and all the other shops on the left of Town Road, has been replaced by a modern shopping centre. The Tabernacle church has long gone, but the older church of St John the Evangelist is being restored for a new life in the community. On the right, many of the original buildings have gone – except for one small piece of the Angel Hotel. If you look closely at the red and cream building, now occupied by a well-known bank, you will see that it is part of the old Angel Hotel.

13

UPPER MARKET SQUARE

A VIEW OF Upper Market
Square, showing goods
being sold from the back
of horse-drawn carts, seen
in the photograph on the
right. Amies' shop sold
'Society Boots'. Next door is
the premises of Williams &
Bedworth, auctioneers. In the
centre of the picture is The
Grapes public house, with
the Angel Hotel next door.
Upper Market Square was
used on market days as an
overflow for market traders.
It began with the bank on
the corner of Market Street
(later Huntbach Street) and
ended with Haynes' milliners
five shops along, where
Parliament Row began.

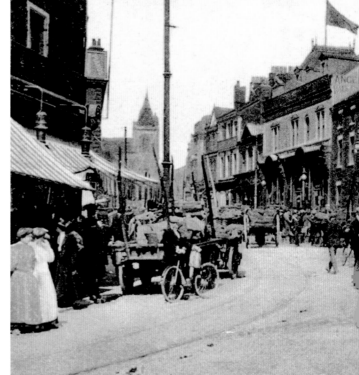

THERE IS STILL a bank on the corner of Upper Market Square and Huntbach Street but the five individual shops have become one modern chemist's store. The Grapes has been demolished, originally to make way for a Halfords' store (though a bank occupies the building today). The only remaining part of the Angel Hotel can be seen on the left of the modern photograph, which was taken early on a Sunday morning because the square is usually full of trading stalls during the week. Upper Market Square is now a paved traffic-free zone, with small trees and hanging baskets of flowers.

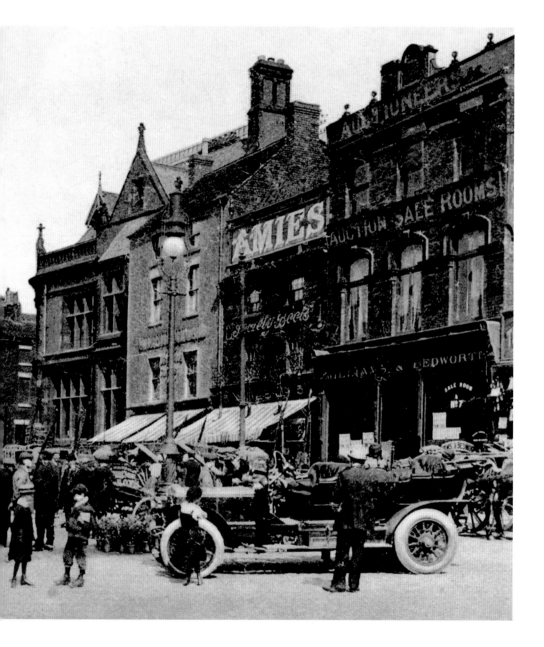

PARLIAMENT ROW

THE PHOTOGRAPH BELOW was captured in around 1900. The large building on the left was the last address in Upper Market Square, and Amies and Sons' was the first address in Parliament Row. W. & H. Acres ran a linen drapers and general tailors' business in this large building from before 1892 until the early 1900s. The building was later used by Williams & Bedworth, auctioneers, and in 1912, until the late 1920s, became the home of the Lyric

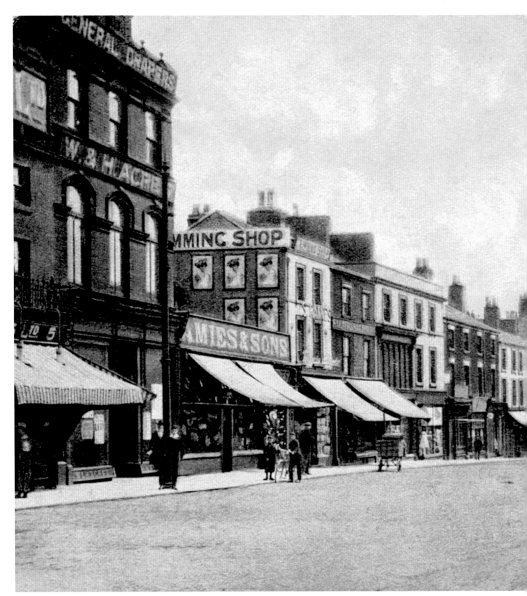

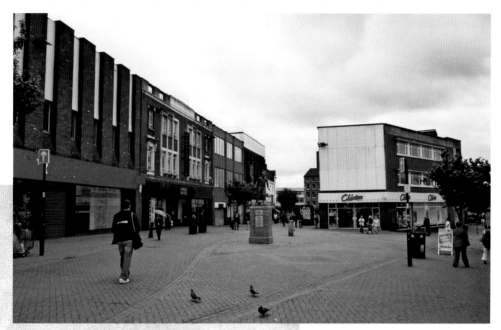

Electric Theatre, one of Hanley's first 'moving picture' houses. Parliament Row carries on to Parliament Square and Old Hall Street. In Parliament Square is the back entrance to Hanley Meat Market. To the right, the road drops into Tontine Square.

EVEN ON AN early Sunday morning, Parliament Row is busy, with many shops open. In the centre of the picture stands a statue of Sir Stanley Matthews, born a few hundred yards from this spot. Nothing remains of the early buildings along this part of Parliament Row but in the distance is Parliament Square, where many Victorian buildings still exist. The old Meat Market is now a book shop and restaurant, while Burton's Stores, one of the older public houses in Hanley, is still popular.

LOOKING TOWARDS
UPPER MARKET SQUARE

THE BUILDING IN the centre of the old photograph below is the Manchester and Liverpool District Bank, situated at the bottom of Market Street and across from The Grapes. Next door to the bank is J.D. Furnival and Co., a chemist, with Amies Ltd, boot maker and dealer, next door.

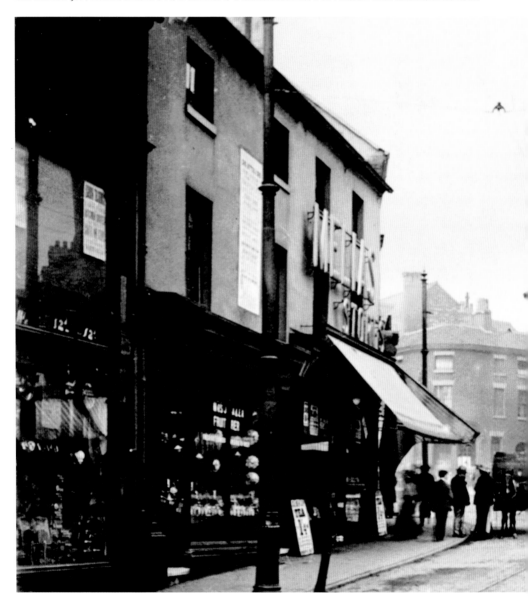

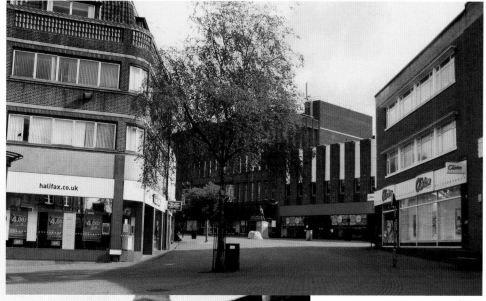

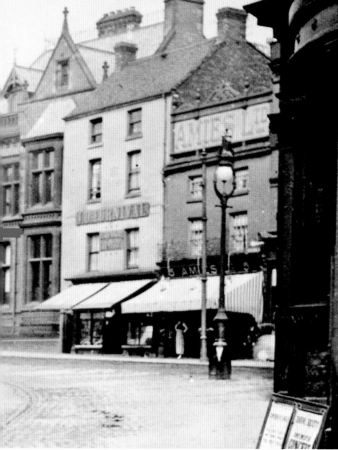

Amies' seemed to have moved premises often during the Edwardian era. To the left is a large grocery store belonging to J. Melia, with Mrs Allen's fruit shop just below. Tramlines pass down into Tontine Square.

NONE OF THE buildings in the old photograph are standing today, though on the corner of Huntbach Street (which used to be Market Street) there is a modern bank with a large and modern chemist shop next door, just as it was 100 years ago. The paved area in Upper Market Square carries on down to Tontine Square and on to Fountain Square and Tontine Street. The building on the right was, for many years, the West Midlands Gas Board shop and offices.

FOUNTAIN SQUARE

A VIEW OF Fountain Square, taken from the front of the old Town Hall in around 1920. Most of the shops seem to be selling shoes and clothing. On the left we can see Batchelor's costume shop and Stead & Simpson's shoe shop. Across the cobbled road is McIlroy's large department store, with Cash & Co. next door. SMC sell shirts and overalls, while Marsden Bros sell boys' clothes. Around

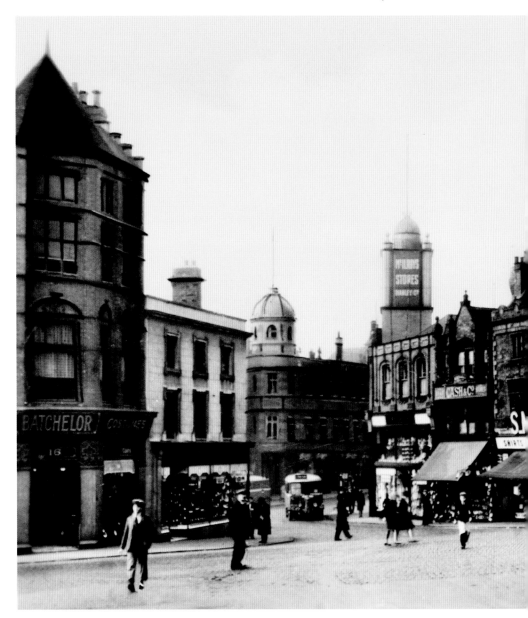

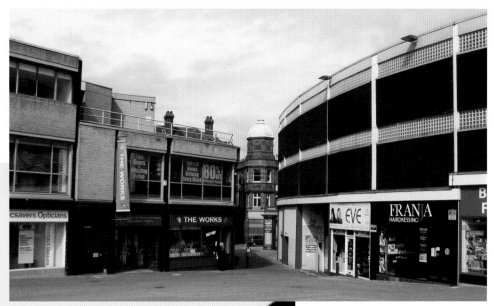

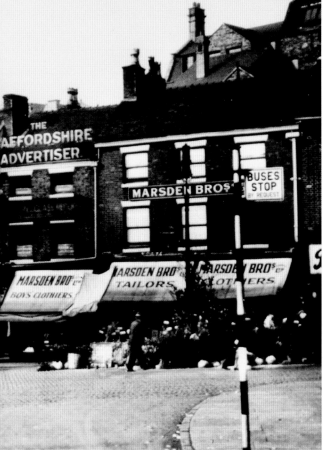

the water fountain, fresh flowers could be bought most days of the week. Fountain Square was also the early home of the *Staffordshire Advertiser*. In the distance can be seen the tower above Teeton's large linen and fabrics store.

NOTHING OF THIS part of Fountain Square remains from the old picture, even the bus route is now just a narrow walkway. During the week, Fountain Square contains market stalls and mobile food outlets. The block paving traffic-free area continues down from Market Square and Tontine Square through Fountain Square and on to Crown Bank and Stafford Street. The rebuilding of Fountain Square began during the 1960s and continued until the end of the century. In the distance the landmark dome of Teeton's old building can be seen.

MARKET DAY,
FOUNTAIN SQUARE

DURING MARKET DAYS the square was used by local nurserymen to sell trees, plants and flowers. This part of the square has seen many changes over the years. Shortly before this picture was taken a water fountain occupied an area just below the street lamp. Much later this part of the square

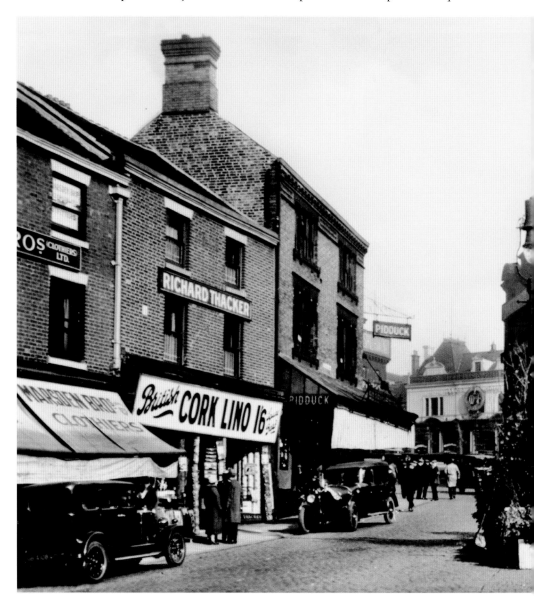

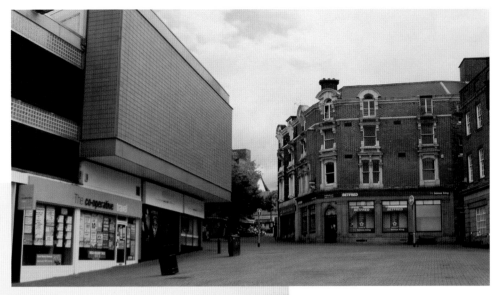

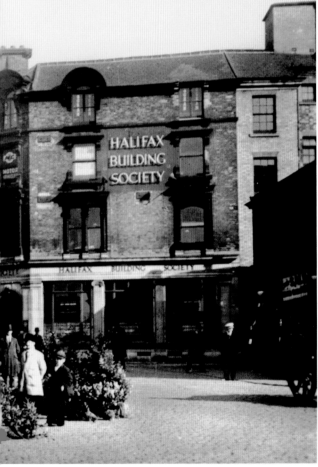

became a roundabout to ease traffic through to Stafford Street. The sombre looking Victoria House on the right is occupied by Halifax bank. Linoleum floor covering was very popular at the time of this picture and the shop of Richard Thacker, on the left, sold 'British Cork Lino' for many years. The shop of Hanley jeweller Henry Pidduck is situated on the corner with Market Square.

ALL THE BUILDINGS on the left have been replaced with more modern buildings. A modern jewellery shop still occupies the corner with Market Square. On the right, Victoria House still stands and the recently cleaned brickwork and brightly painted windows give the building a brighter look. In the centre of the picture, behind the tree, the last remaining part of the Angel Hotel can just be seen. During the week this busy square is crowded with shoppers and street stalls.

TEMPERANTIA, FOUNTAIN SQUARE

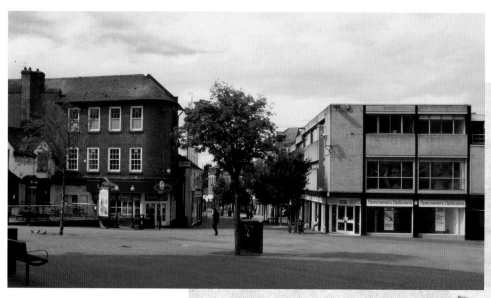

FOUNTAIN SQUARE, LOOKING down towards Crown Bank, Stafford Street and Piccadilly, can be seen in the photograph on the right from around 1915. The public house on the far left is Ye Old French Horn, one of the oldest public houses in Hanley. The white building is a grocery shop occupied by George Mason. Further down on the left, towards Stafford Street and Piccadilly, is a sweet shop belonging to F.G. Baddeley; the tall building at the end of the row is the Dolphin Inn. In this pre-1920 picture the bronze statue of Temperantia, a Roman goddess who embodies the concept of temperance and moderation, and the water fountain can be seen on the right.

IN THE MODERN photograph opposite, Ye Old French Horn public house still stands but has changed its name to The Metro. George Mason's corner grocery shop has been rebuilt, but further down the old sweet shop and the Dolphin Inn still stand (albeit with new owners). The Roman goddess Temperantia was removed to Northwood Park in 1920, only to be replaced when the square was first pedestrianised in the late 1960s. She was removed again shortly after due to vandalism. In 2007 Temperantia was a centre of attraction when Northwood Park celebrated the park's centenary. All over Hanley there are mature trees growing, and the one in this picture restricts our view of Piccadilly.

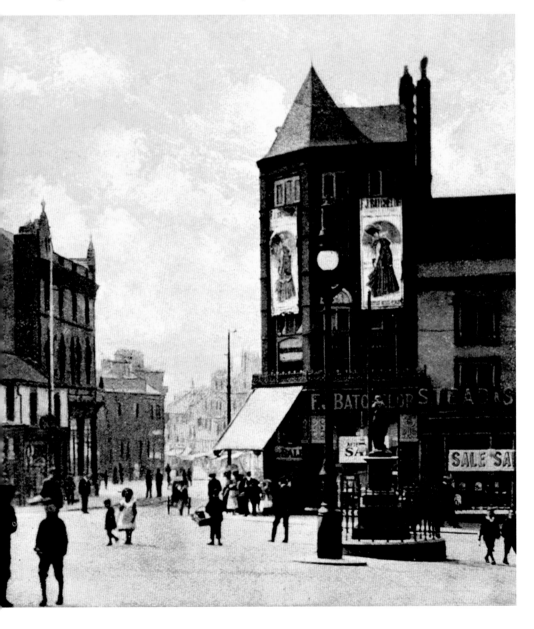

STAFFORD STREET FROM FOUNTAIN SQUARE

BUILT FOR TEETON'S Ltd in 1911 on the site of their previous shop, this imposing red brick and terracotta building is one of the most beautiful in Hanley. Teeton's were an old and established draper's, taking over the business of Arthur Cotterill in the early 1890s and still trading in 1938. On the right is McIlroy's Stores, who started in 1883 and grew to be one of the largest

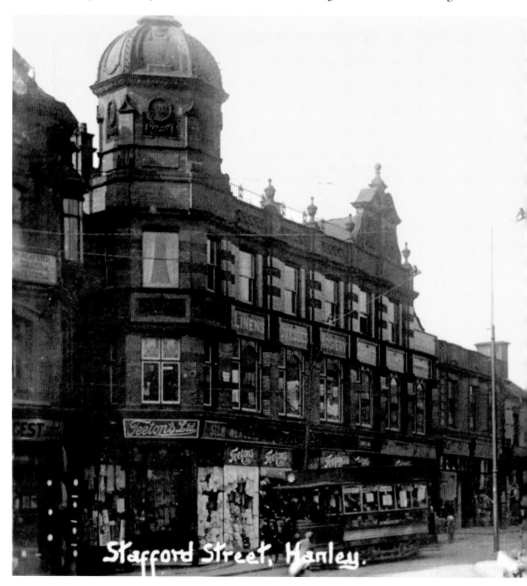

Stafford Street, Hanley.

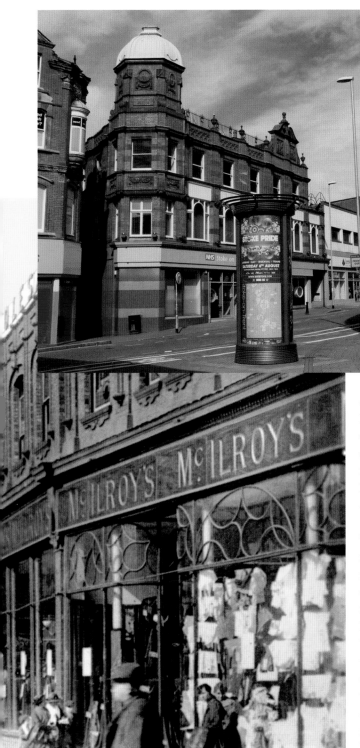

department stores in the Potteries. Stafford Street is one of the longest streets in Hanley, starting at Albion Square and running all across Hanley to Hope Street, Old Hall Street and Bryan Street.

THIS BEAUTIFUL BUILDING is now occupied on the ground floor by an NHS drop-in centre. The building retains its copper-covered dome, a Hanley landmark, and the beautiful ornamentation at the top of the building still seems to be intact. Some of the buildings further along Stafford Street have been replaced, and on the right McIlroy's has long gone.

HANLEY OLD TOWN HALL

THE DOMINANT BUILDING in the centre of the old photograph below is Hanley's old Town Hall. Built in the early 1840s, it also acted as an early police station with cells in the basement. The old Town Hall also boasted a public newsroom where newspapers could be read. In 1886 the building was taken over by Lloyds TSB Bank, as shortly before, the Queen's Hotel in Albion

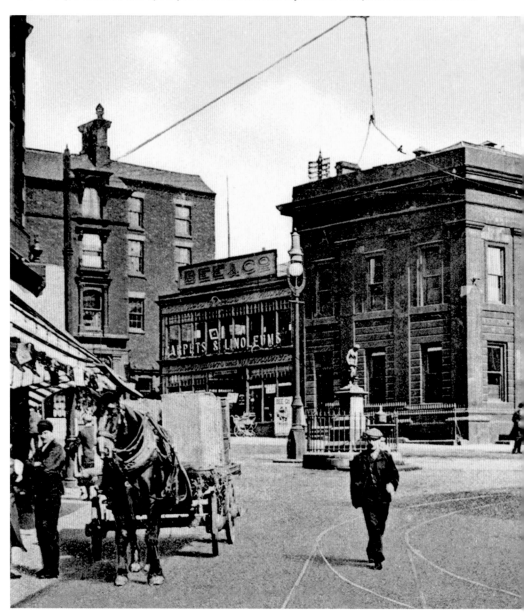

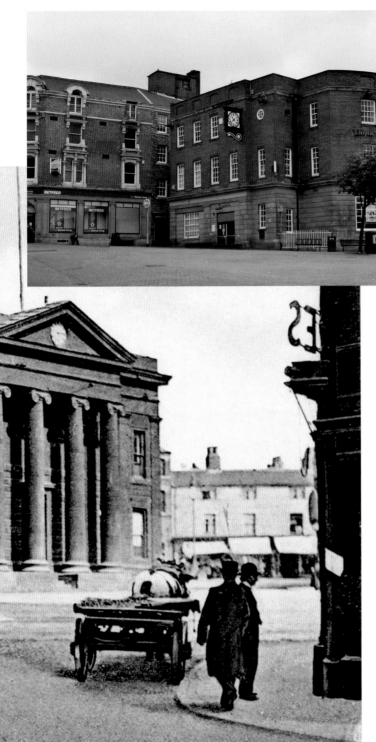

Square had been converted into the new Hanley Town Hall. To the left of the old Town Hall is the carpet and linoleum shop of Bee & Co. To the far right is Tontine Square.

HANLEY OLD TOWN Hall was demolished and this fine new building opened in 1936. The new building is still a Lloyds TSB Bank. Victoria House, on the left, has changed occupiers many times since it was built. For a long time it was the home of the Halifax Building Society. Today it is occupied by a betting shop on the ground floor and offices above.

HANLEY NEW TOWN HALL

HANLEY TOWN HALL began life as the luxurious Queen's Hotel and was officially opened during December 1869 with a magnificent banquet and ball. The building cost £15,000 – plus architect Mr Robert Scrivener's fee of £450 – and boasted an ice house and a laundry. The ground floor had a large commercial room, a showroom, a writing room, a smoke room, a large dining hall, a private billiard room, a butler's pantry and porter and luggage rooms. The hotel bar was placed in the centre of the building. The first floor had two private sitting rooms and fourteen bedrooms.

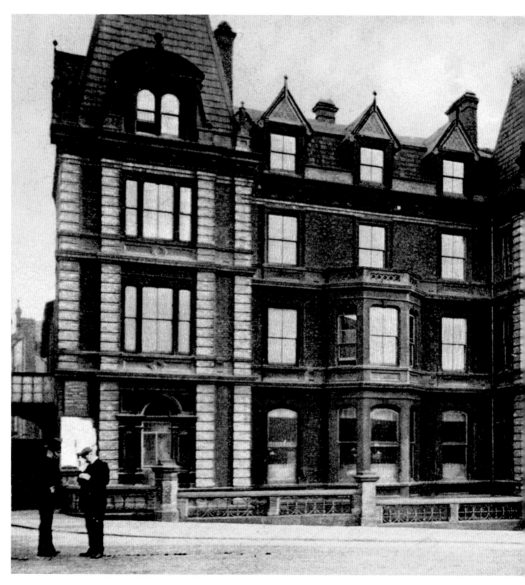

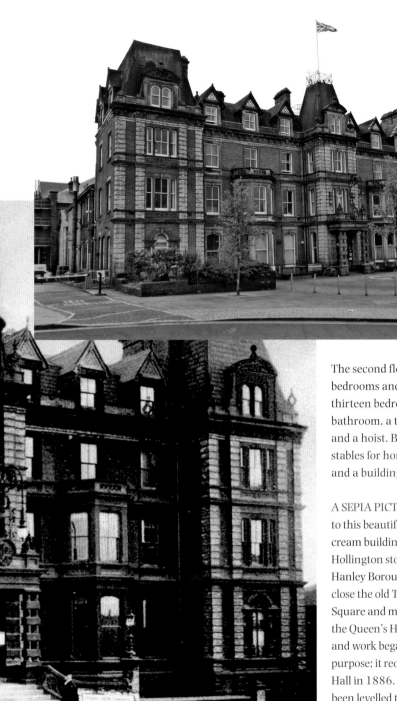

The second floor had eleven bedrooms and the third floor had thirteen bedrooms. Every floor had a bathroom, a toilet room, linen rooms and a hoist. Behind the hotel were stables for horses and their grooms and a building for carriages.

A SEPIA PICTURE cannot do credit to this beautiful terracotta red and cream building with dressings in Hollington stone. In the 1880s Hanley Borough Council decided to close the old Town Hall in Fountain Square and move all the services to the Queen's Hotel in Albion Square, and work began to adapt the hotel for purpose; it reopened as Hanley Town Hall in 1886. The road outside has been levelled to make a large public space, ideal for the many weddings and other ceremonies that are held in the building.

TONTINE SQUARE

IN THE CENTRE of the picture, on land once occupied by the ironmongery shop of James and Tatton, is an art deco period building occupied by J.H. Ball and Sons, furniture dealers. To the left is the old Town Hall and the premises of Richard Thacker, house furnisher. To the right is the pet shop belonging to T. Newman, with Boyes' radio and wireless shop next door. The cobbled

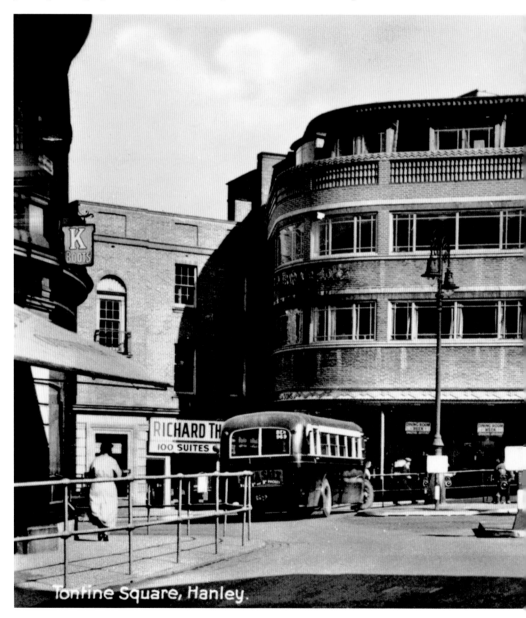

Tontine Square, Hanley.

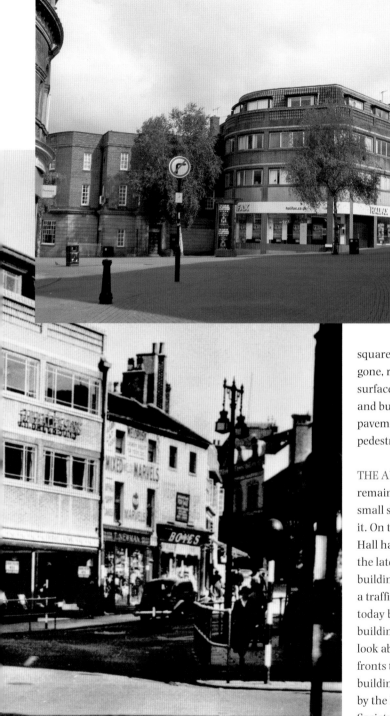

square and tramlines have gone, replaced with a road surface suitable for motor cars and buses, with fenced-off pavements to keep the pedestrians safe.

THE ART DECO style building remains today, as do the two small shops to the right of it. On the left, the old Town Hall has been replaced by the later Lloyds TSB Bank building. Tontine Square is a traffic free pedestrian area today but still has many old buildings: all you have to do is look above the modern shop fronts to see them. The centre building has been occupied by the Halifax Building Society for many years.

TONTINE STREET

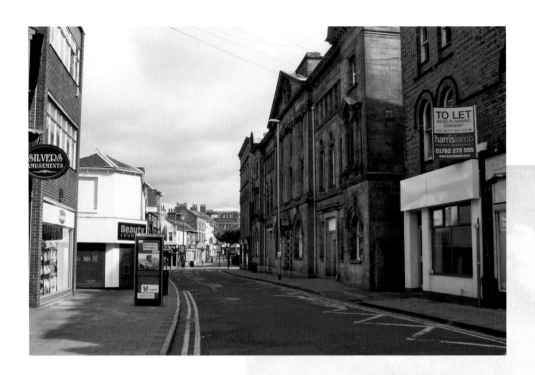

THE TWO MOST dominant buildings in Tontine Street stand side by side, with the old post office prominent in this picture and the Free Trade Building further along. Built in 1906 at a cost of £13,000, this was the main post office for the whole area. To the right is the butcher's shop of Henry Turner with the saddle- and harness-making shop of E. Bridgwood next door. The other prominent building to the left of the post office is the Free Trade Building, which contained the printing works of Hill & Ainsworth. Looking down the left of Tontine Street (and at the beginning of Stafford Lane) is the tobacconist's shop of Mrs E.M. Boulton, but not much can be seen of the other shops until the road is crossed by Percy Street. On the

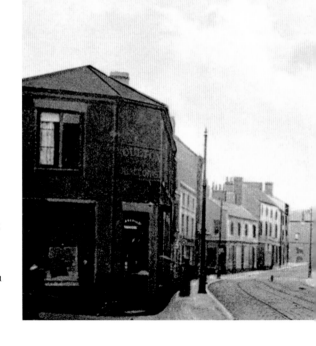

corner of Tontine Street and Percy Street are the refreshment rooms belonging to M. Cartlidge, and further along is the Tontine Wine Bar. The building at the end of Tontine Street – located in Tontine Square – is the large ironmonger's shop belonging to James and Tatton.

HANLEY'S OLD POST office building is still dominant in Tontine Street but sadly closed in 2007, just over 100 years since it opened. The butcher and the saddle-maker have gone and the building is waiting for a new business. To the left of the old post office is the Free Trade Building once occupied by Hill and Ainsworth, now belonging to Webberley's printers and book shop. Mrs Boulton's tobacconist shop is now a beauty lounge and Cartlidge's refreshment rooms are a fast-food outlet. James and Tatton's shop in Tontine Square was replaced by a lovely art deco style building, which can be seen in the centre of the picture.

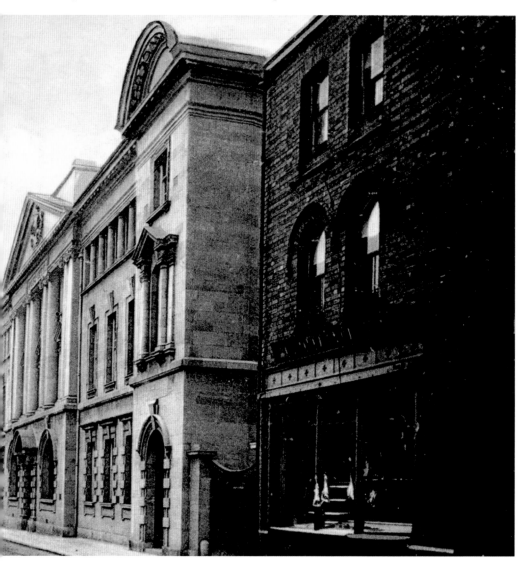

ALBION SQUARE

ALBION WORKS, THE pottery of Thomas Dimmock (and later John Dimmock & Son), stood from early 1822 until its demolition in 1905; occupying land between Stafford Street and Cheapside, the felling of Dimmock's chimney must have been quite a spectacular sight, judging from this picture. The event drew a large crowd and postcards of the event were produced and sold shortly after. This picture was possibly taken from the top floor of the Albion Hotel in Albion Square, looking towards the top of Stafford Street. Albion Square was named after Dimmock's Albion Works.

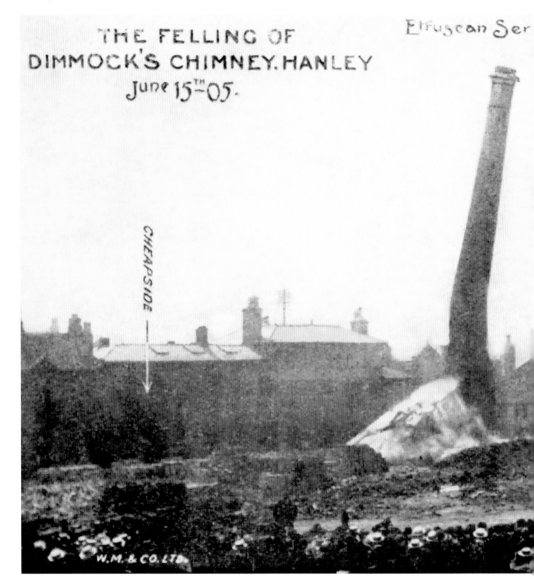

THE FELLING OF
DIMMOCK'S CHIMNEY. HANLEY
June 15ᵀᴴ 05.

Etruscan Ser

CHEAPSIDE

W.M. & CO. LTD.

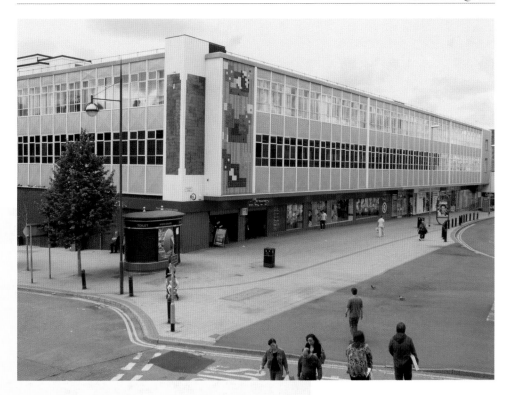

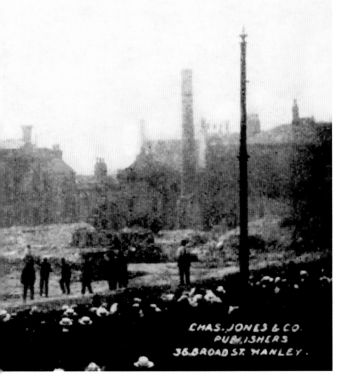

CHAS. JONES & CO.
PUBLISHERS
36. BROAD ST. HANLEY.

THE SITE ON which John Dimmock's pottery stood has changed its appearance many times over the past 100 years. First to be built on the site was the Olympia Skating Rink, which later became a dance hall. In 1932 the dance hall was refurbished and reopened as the Palace Cinema. The Palace later changed its name to the Essoldo Cinema, and closed its doors in 1962. After the Essoldo was demolished, the building in the picture was erected on the site. This large structure housed a dance hall, a large department stall, small shops and offices. Today it houses a bingo hall, a large 'sell everything' type shop, and small retail shops with government offices on the upper floors.

THE OLD COTTAGES,
STAFFORD STREET

THESE TWO SMALL cottages in Stafford Street were demolished in about 1905 to make way for Gough's Garage and Cycle shop – a shame because these cottages were thought to be some of the oldest in Hanley. According to a Hanley census, the house in the centre of the picture had not been occupied since before 1881 and was used as a store for hay and straw by a local dealer.

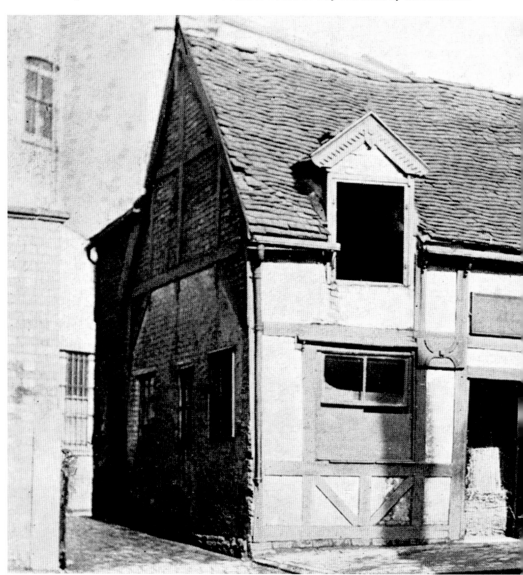

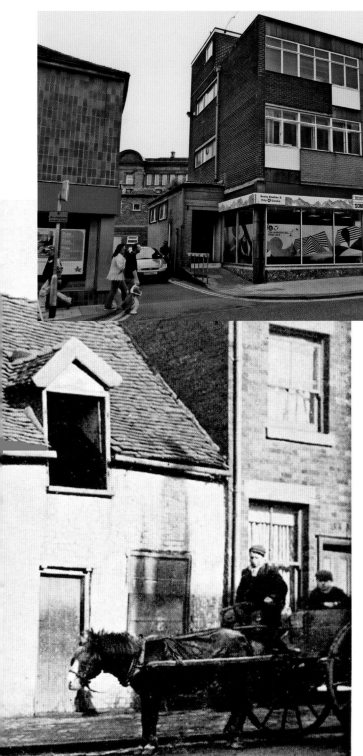

The alley to the left leads to Stafford Lane and on to Tontine Street. Across the alley (and just to be seen on the left) is the Black Swan public house.

THE ONLY THING that remains from the old picture is the alley, which still leads to Stafford Lane and on to Tontine Street. All this part of Stafford Street has been rebuilt, starting in the 1970s. To the left of the alley was once the business for Thomas Cook, and then for a short time an Automobile Association shop; later still it was an optician's. Where the old houses were built has become one large plot containing small businesses on the ground floor and a snooker club on the first floor.

STAFFORD STREET
AND CROWN BANK

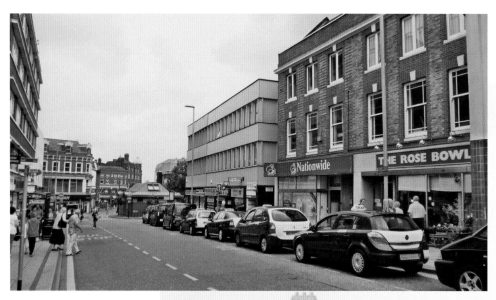

SOLID-WHEEL BUSES stand and wait at the corner of Stafford Street and Crown Bank in the old photograph on the right. On the corner is the tailor F. McKnight & Sons, No. 32 Stafford Street, and next door are the premises of Arthur M. Moss, an architect and surveyor. To the left, at the top of Piccadilly, is the tailor's shop of J.J. Woodford. This later became a gentlemen's outfitters for Dunn & Co. The back of this postcard says that the large crowd in the centre of the picture has gathered for a First World War recruitment campaign.

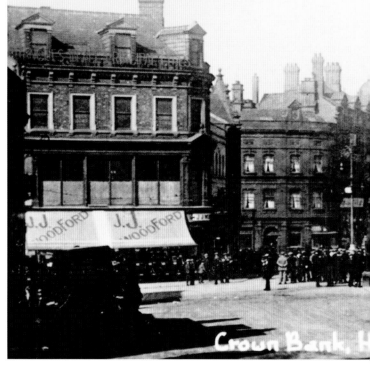

STAFFORD STREET IS now a one-way street: the buses pick up on the left of the picture, and taxis have replaced them on the right. The buildings of McKnight and Moss have been replaced with a 1970s construction consisting of shop premises on the ground floor and offices above. The building on the right replaced the architect and surveyor's premises of Arthur M. Moss during the 1930s. Stafford Street will undergo new traffic regulations in 2012, making it a bus and access only zone.

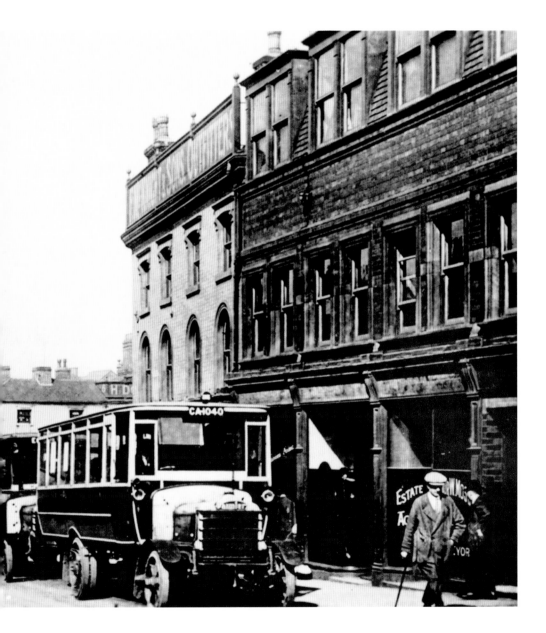

STAFFORD STREET AND CROWN BANK CONTINUED

ON THE LEFT, and parked in front of Burton's gentlemen's outfitters, is a bus belonging to
C. Knight and Sons, Birches Head. Just past the bus on the left is the start of Piccadilly, and
the building with the large sun canopy is the tailor's shop of J.J. Woodford. The white building
to the right of the centre is a branch of the Westminster Bank. On the right are underground

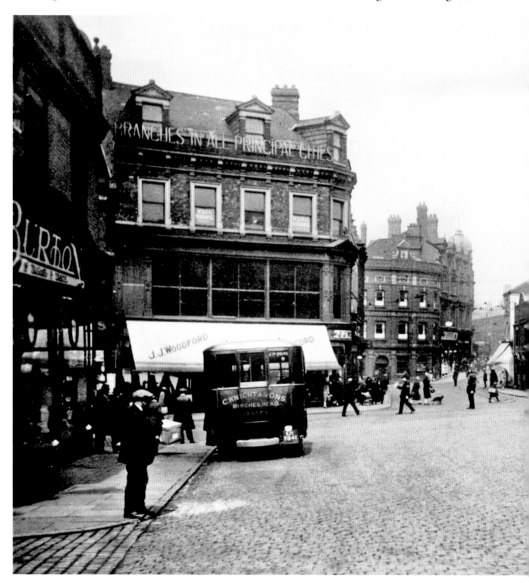

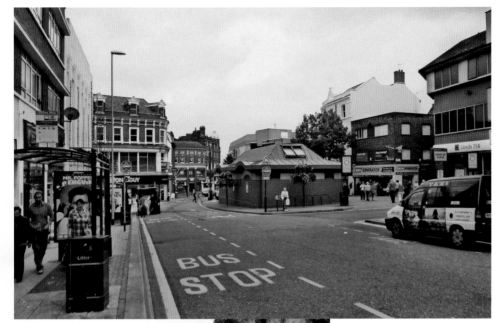

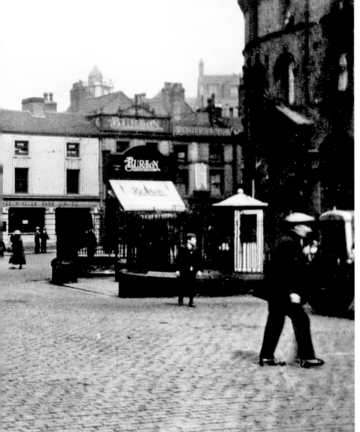

public toilets and the building to the far right is the Dolphin Hotel.

THE LEFT SIDE of Stafford Street is still a place where buses stop to pick up passengers, and many of the buildings in this area can be seen in the old picture. The white building behind the tree is the old Dolphin Hotel and the centre of Crown Bank is now dominated by a large above-ground modern public toilet. The corner building to the left of centre, which once held Woodford's tailors and later the gentlemen's outfitters of Dunn and Co., now has a hairdresser's on the ground floor.

43

THE OLD POTTERY SITE

BUILT IN AROUND 1867, the pottery manufacturing works of Bishop and Stonier occupy the centre of the old photograph below. Still operating in Stafford Street in 1924, the old pottery site had been acquired by Lewis's by 1936. Earlier, Lewis's had obtained McIlroy's general store and opened their first Hanley shop on this site. Later, after Lewis's had obtained the old pottery site,

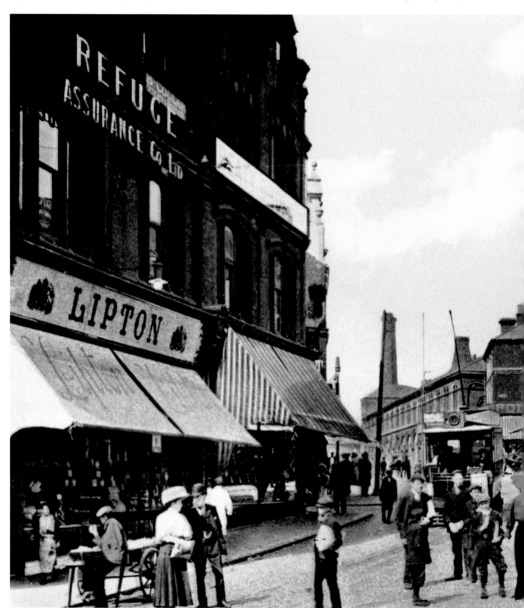

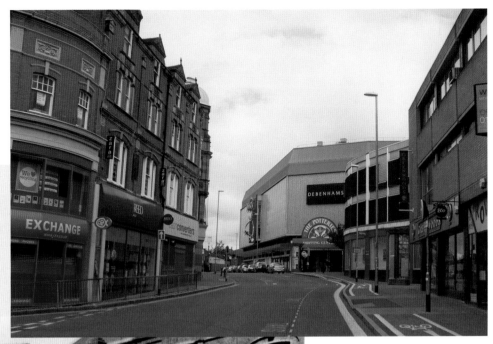

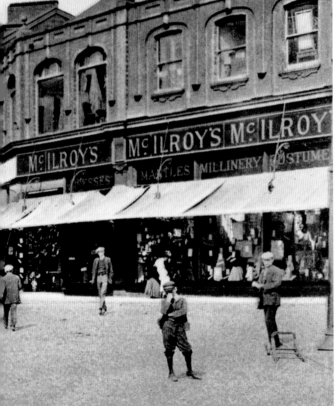

they built the largest departmental store in the Potteries and moved from the old McIlroy's building to the new store. The bottom of Lamb Street can be seen branching up to the right.

THE WONDERFUL OLD buildings on the left have only changed at ground level, where the old shops have been replaced with modern businesses. The blue building in the centre is on the site of the old pottery works (Lewis's Arcade and department store until 1998). In the centre, at the end of the street and attached to the Debenhams' department store, is a beautiful 35ft high anodised aluminium sculpture titled 'The Man of Fire' – though local people have renamed him Jack Frost.

LEWIS'S DEPARTMENT STORE

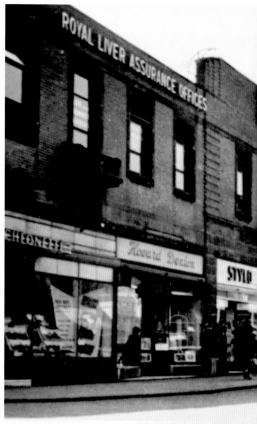

BY THE TIME the photograph on the right was taken the pottery of Bishop and Stonier had gone, replaced by Lewis's department store and arcade. The upper floors of the building on the left contain not only Lewis's but also offices for Royal Liver Assurance Company. Many different shops used the ground floor, and below the two flag poles is the entrance to Lewis's Arcade. To the left is the beginning of Bryan Street and on the right is Old Hall Street.

IN 1963, LEWIS'S built the blue building on the left and opened it as their new Hanley department store. The Potteries Shopping Centre

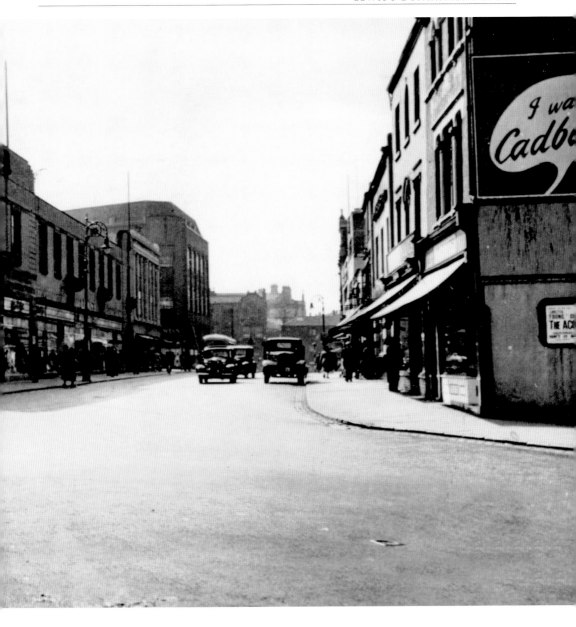

was joined onto Lewis's store in 1988 and then Lewis's was taken over by Owen and Owen in 1998, reopening the store as Debenhams. The 'Man of Fire' can be seen on the side of the blue building. The right-hand side of the street has not changed much in the past 100 years – just the ground-floor shop fronts. This end of Stafford Street leads to Cobridge and then on to Burslem. The red building on the right is a popular wine bar and the white building next door is unoccupied. All the buildings that occupy the far centre of the picture are modern.

LAMB STREET

A VIEW OF Lamb Street looking from the bottom of Market Square towards Stafford Street (below). M. Huntbach & Co. had a store on the left but later moved across the road to occupy one of the largest department stores in Hanley. W.S. Brown & Sons, butchers, have the shop in Stafford Street (which is in the centre of the picture). Brown's owned another shop in Broad

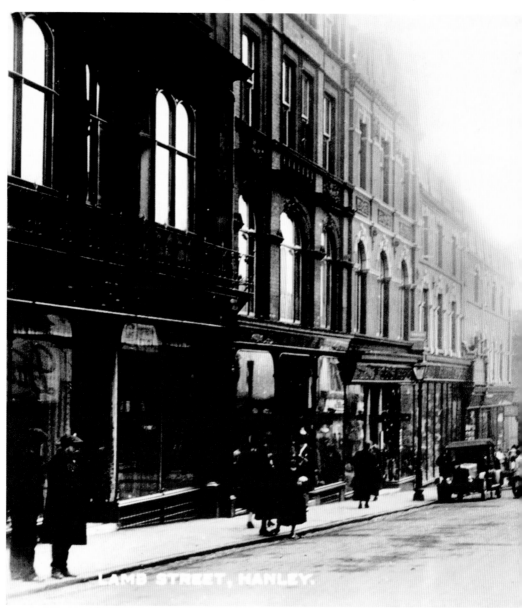

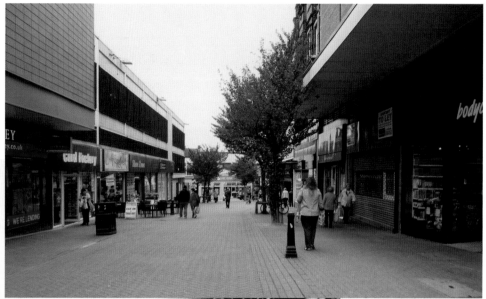

Street which also contained their abattoirs. Many of the tallest buildings in Hanley can be found in Lamb Street.

BEGINNING IN MARKET Square and containing mature trees and hanging flower baskets, Lamb Street today is a busy paved pedestrian street and an important part of Hanley's shopping experience. The modern shopping stores on both sides have replaced all the large Edwardian buildings except for one, which can just be seen halfway down Lamb Street on the right.

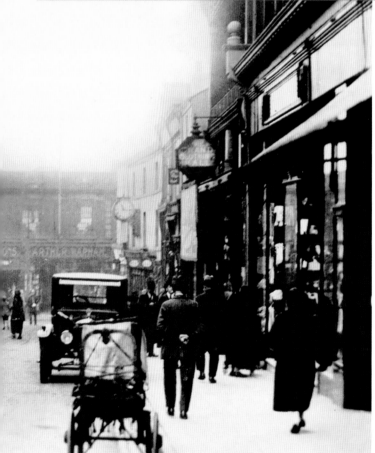

49

THE GRAND THEATRE
AND TRINITY STREET

THE GRAND THEATRE of Varieties and Circus, on the corner of Trinity Street and Foundry Street, was opened in August 1898 at a cost of £20,000. It was designed by Frank Matcham and built by Thomas Goodwin of Hanley. The Grand was noted for having a stage 63ft wide and 44ft deep that could be removed when required. This was particularly beneficial when the circus came to town, as a circus arena could be made to replace the stage. The theatre always seems to have had moving pictures on the bill and was converted into a full-time cinema in 1932. Shortly after the conversion, the Grand was burnt down. It was rebuilt as the Odeon Cinema and re-opened in February 1937 with the film *Educated Evans*. The Odeon Cinema

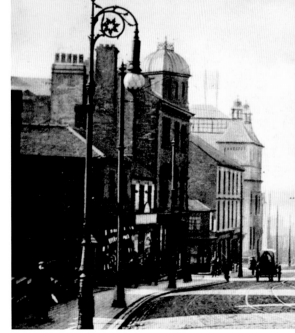

attracted many classic films for long runs, including *South Pacific* and *The Sound of Music*, and in 1952 it held the provincial premiere of the film of Arnold Bennett's book *The Card*, which contained many scenes filmed in the Potteries.

TRINITY STREET IS the main road out of Hanley, through Etruria and on to Newcastle-under-Lyme. The building on the right replaced the old Grand Theatre in 1937 when the Odeon Cinema was opened. The Odeon itself closed in 1975 and the building was later split into a number of smaller entertainment venues. The cream building in the centre of the picture is the Grand Hotel, which opened on 19 January 1900.

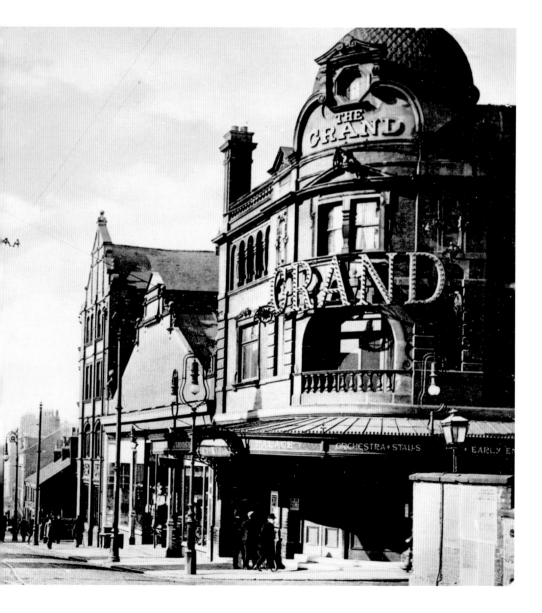

THE PRIMITIVE METHODIST CHAPEL, MARSH STREET

THIS PRIMITIVE METHODIST Chapel was one of many built in Hanley after the All Day of Prayer held at nearby Mow Cop in 1807. Standing on the corner of Marsh Street and Brunswick Street, this little chapel initially flourished, holding two well-attended services each Sunday. After the chapel closed it became the home of the North Staffordshire Boy Scouts' Association Headquarters and a Blacks Outdoor Clothing shop.

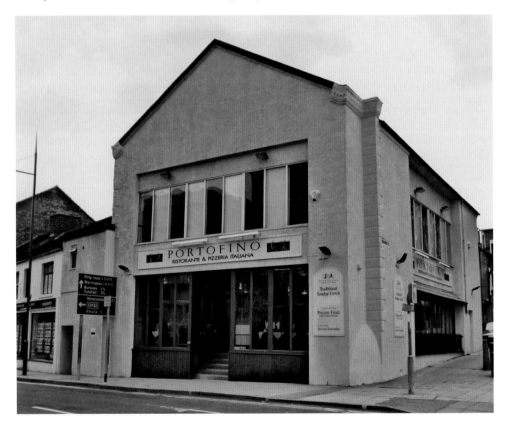

FOR MANY YEARS this ex-Primitive Methodist Chapel was used by Blacks as an Outdoor Centre shop, but they left in the 1990s and much later the chapel became the home of this popular restaurant. Very little remains of the building's original look, with all traces of the old front removed and rendered over.

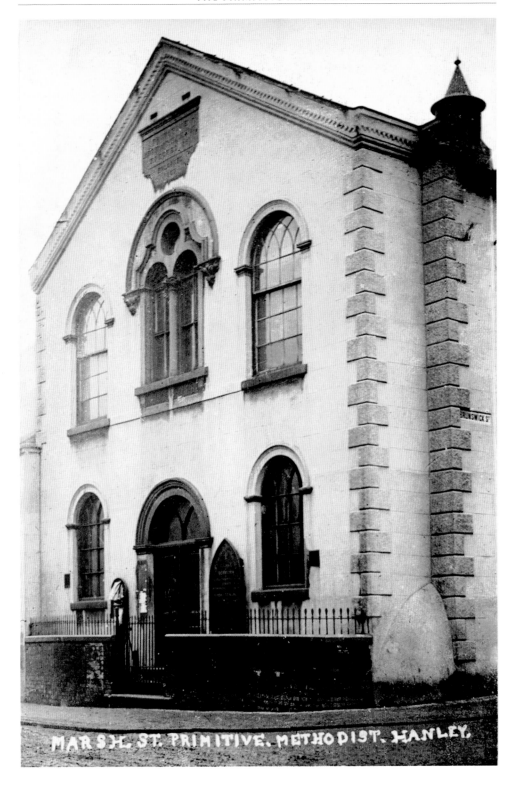

THE TOP OF BROAD STREET

SITUATED AT THE bottom of Piccadilly, this large square is not identified by a name. To the right are Crane and Sons Ltd, piano and organ manufacturers, whose address was 15 Exchange Buildings, Piccadilly. Next door, to the left, is the King's Head Hotel, Piccadilly. On the opposite corner is the drapery shop of H. Field. The large building on the left was built by a dentist for his family business, but in the photograph on the right it belongs to the British Gaslight Co. Ltd, with a linen shop and a

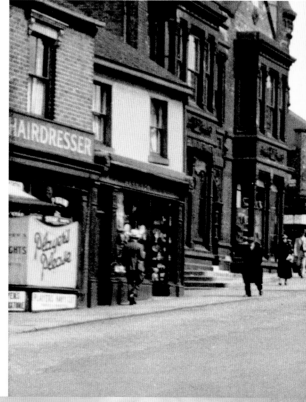

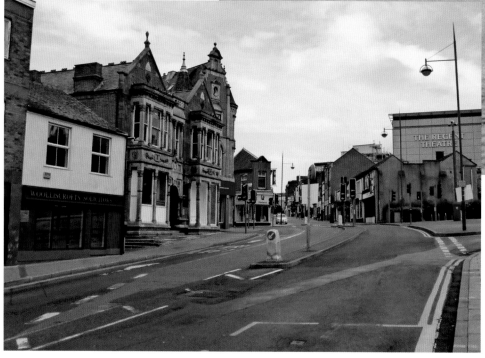

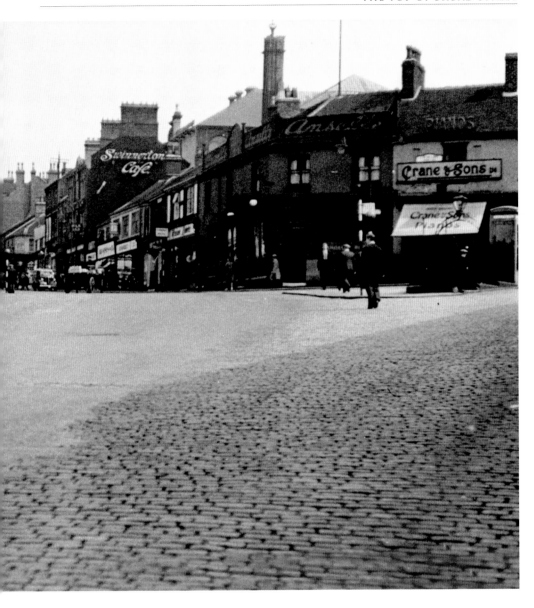

tobacconist's and hairdresser's further down Broad Street. On the far right are railings to protect the underground public toilets.

THE KING'S HEAD Hotel and Crane's shop have gone, with a small garden and seating area in their place. The underground public toilets have gone too, to accommodate a multi-road junction, but almost all of the buildings in this picture are over 100 years old and can be identified in the previous picture. The linen shop is now a solicitor's and the British Gaslight building is occupied by Airspace Contemporary Art Gallery. On the right – overlooking this part of what is known as the Cultural Quarter – is the recently modernised Regent Theatre.

PICCADILLY

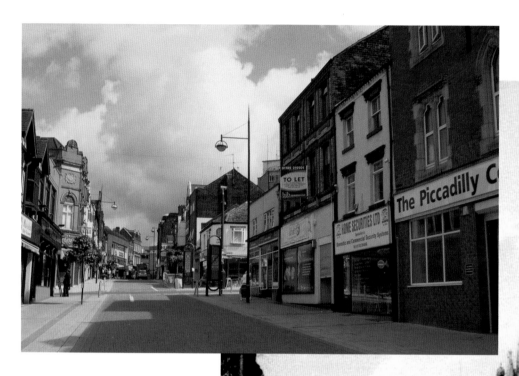

IN EDWARDIAN HANLEY, Piccadilly was one of the most important streets, being the main tram route to Shelton and Stoke. The street crossing Piccadilly just above the tram is Pall Mall. Cheapside was located near the top of Piccadilly, and together these three streets were known as the London Streets. There are many shops in Piccadilly, selling all kinds of goods and produce. On the right is the ladies' tailor and fancy draper's shop of M. Proctor; next, the boot and shoe maker Baker and Sons', and then the tailor's shop of C. Evans. In the window of the photographer's shop belonging to J. H. Glover & Co. are many picture frames, and the last in the row is the Rose & Thistle inn.

THE GROUND-FLOOR shop fronts may have changed but the buildings still remain. The draper's building is now used by the NHS, and Evans' is a security installation shop. The building next door is no longer in use, and where the Rose & Thistle used to be is now an estate agents'. The Pall Mall crossroads can be easily seen in this picture. The whole of Piccadilly is a paved pedestrian area.

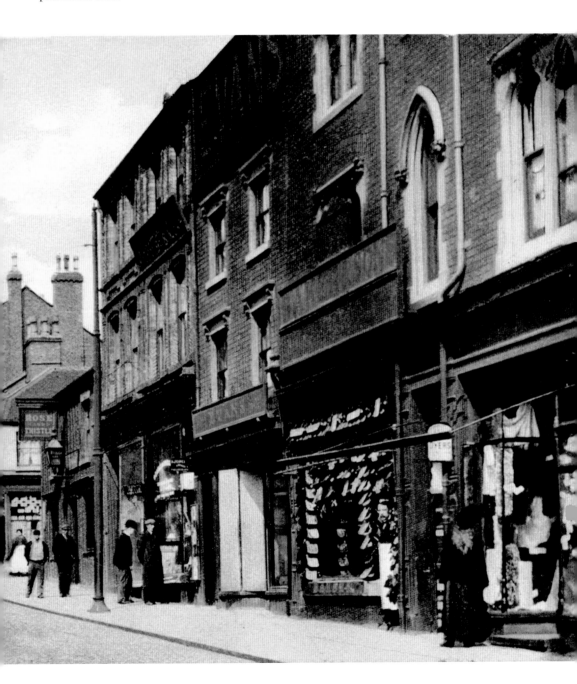

BURTON'S, PICCADILLY

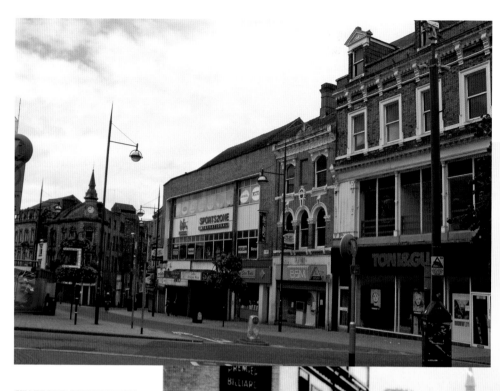

STAFFORD STREET RUNS between Crown Bank and Piccadilly. The building on the left started life as the Shakespeare Hotel but by the time the photograph on the right was taken it had transformed into Burton's gentlemen's outfitters. The Premier Billiard Hall could be found on the first floor. Buses to Stoke and Burslem are waiting on the cobbled road outside. The building with the clock tower was the early home of Boots, and Brunswick Street falls away in the centre of the picture.

THE LARGE LAMPPOST at the top of Piccadilly has been replaced with a CCTV installation, and the public transport buses to Stoke no longer leave from the left side of the road. Two of the lovely old buildings on the right are still there, and a sign informs visitors that Piccadilly is a gateway to the city's Cultural Quarter, leading to the Regent Theatre and the Potteries Museum and Art Gallery. The building on the right is now a hairdresser's, and Pool's ironmongers was once occupied by BSM Driving School but is currently unoccupied.

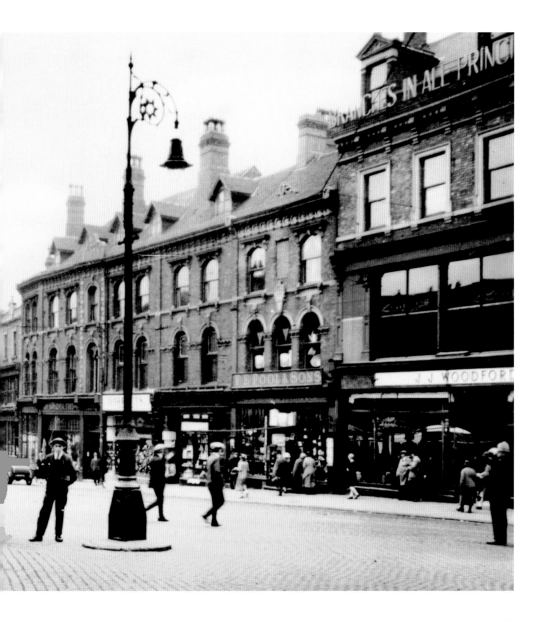

THE PICCADILLY
STAMP SHOP

THE OLD PHOTOGRAPH below can be dated to before 1912 because of the third shop on the left: here (in around 1907) it is the tailor's shop belonging to A. Brown, but it was occupied by Rose &

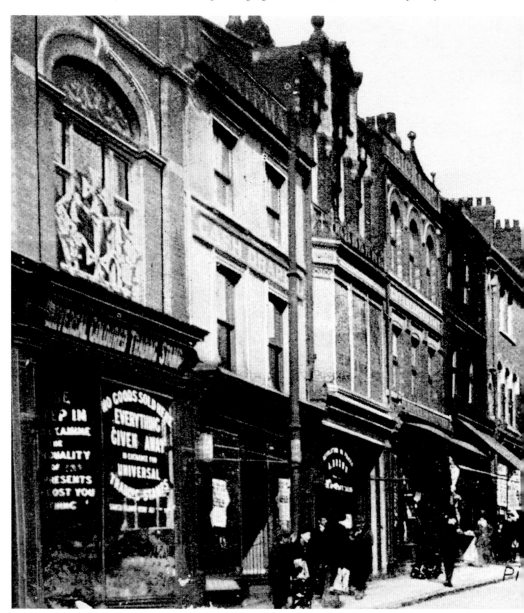

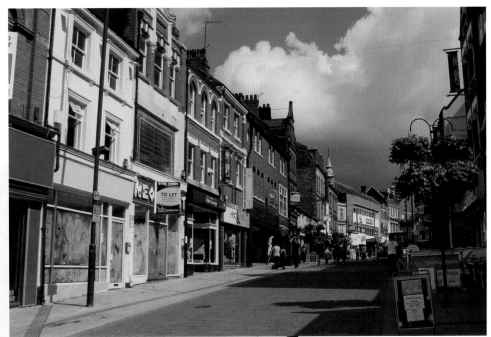

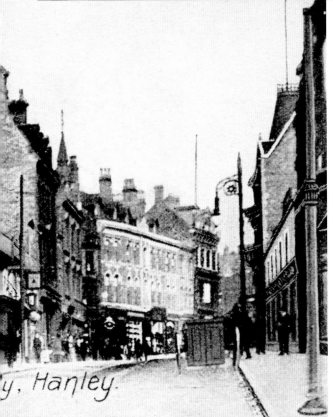

Co. by 1912. The building on the left is situated on the corner of Piccadilly and Pall Mall and is an early example of the use of trading stamps to obtain goods. Just past the centre of the picture, among this row of high buildings, is a small row of ground-floor buildings – among which is the Unicorn Inn, another of Hanley's oldest inns.

THIS VIEW OF the buildings in Piccadilly has not really changed in over 100 years – only the ground-floor shops have altered in appearance. The Unicorn Inn is still a popular meeting place. Piccadilly is a paved pedestrian street and part of the Cultural Quarter with colourful hanging baskets, outdoor seating at cafés and a street chess board outside the Regent Theatre.

LOOKING DOWN PICCADILLY

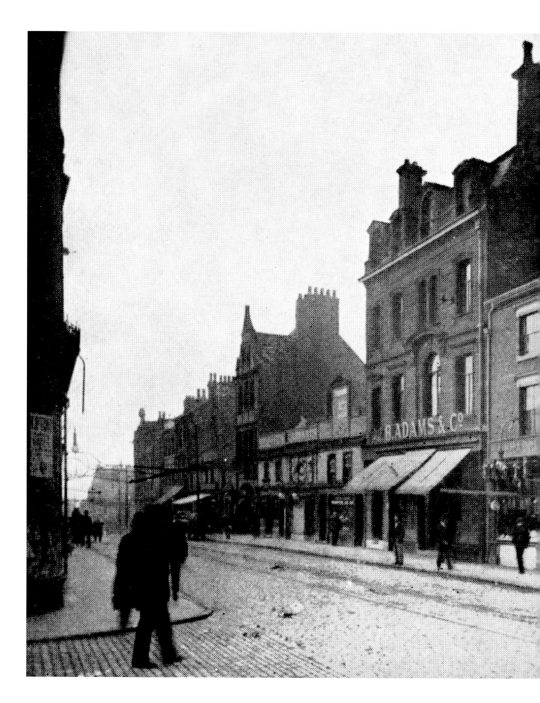

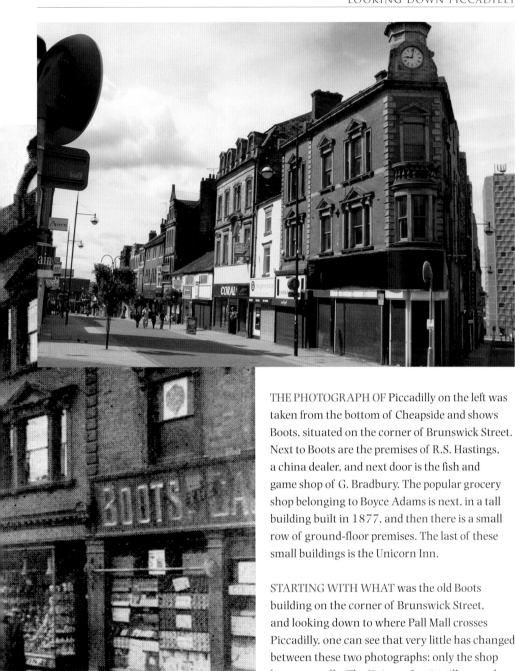

THE PHOTOGRAPH OF Piccadilly on the left was taken from the bottom of Cheapside and shows Boots, situated on the corner of Brunswick Street. Next to Boots are the premises of R.S. Hastings, a china dealer, and next door is the fish and game shop of G. Bradbury. The popular grocery shop belonging to Boyce Adams is next, in a tall building built in 1877, and then there is a small row of ground-floor premises. The last of these small buildings is the Unicorn Inn.

STARTING WITH WHAT was the old Boots building on the corner of Brunswick Street, and looking down to where Pall Mall crosses Piccadilly, one can see that very little has changed between these two photographs: only the shop keepers, really. The Unicorn Inn is still a popular venue, with seating outside. In the far distant bottom of Piccadilly, the Potteries Museum and Art Gallery can be seen. On the far right at the bottom of Brunswick Street is the modern Telephone Exchange building.

63

CROWN BANK FROM
THE TOP OF PICCADILLY

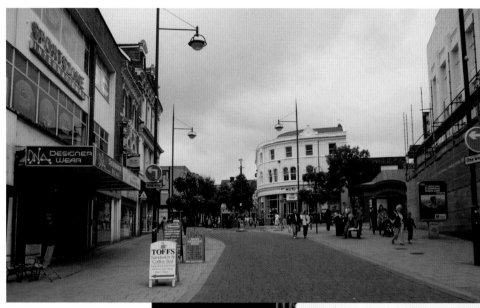

THE BUILDING IN the centre of the photograph on the right is the Dolphin Hotel, mentioned in Pigots' directory for 1829 as the Dolphin Inn. A *Sentinel Summer Special* published in 1911 indicates that the present building was built in about 1840. To the right of the Dolphin Hotel is Capper's grocery shop, and to the left of the Dolphin Hotel is Fountain Square leading on to Market Square.

THE OLD DOLPHIN Hotel proudly stands where it

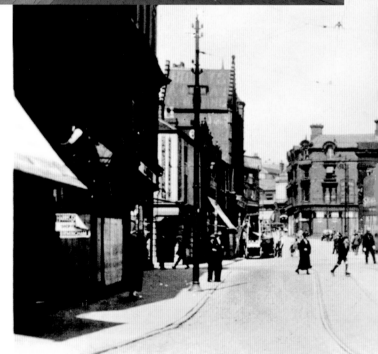

has stood for over 150 years. No longer running as a hotel, the building has been the home of a branch of the HSBC Bank for a long time. Like most of Hanley, Crown Bank and Piccadilly are now block-paved pedestrianised shopping areas with mature trees, hanging baskets and traffic restrictions. Some of the Victorian buildings can still be seen at the top of Piccadilly. The buildings on the right replaced the old buildings during the 1920s and were occupied by Burton's gentlemen's outfitters. This corner with Strafford Street was always known as Burton's Corner.

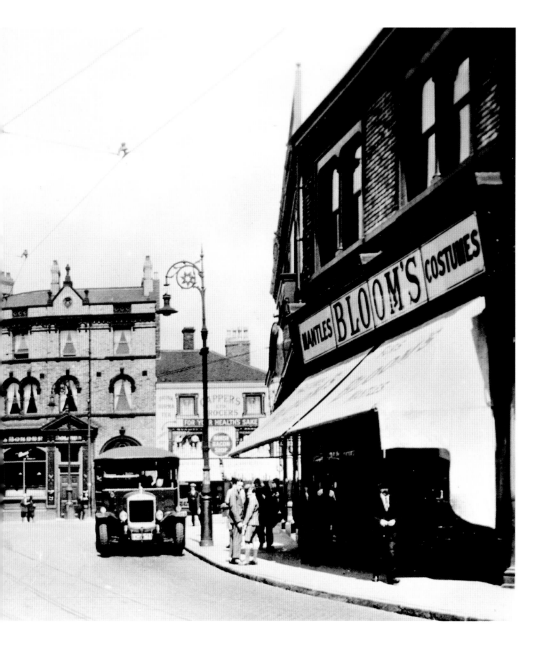

PALL MALL

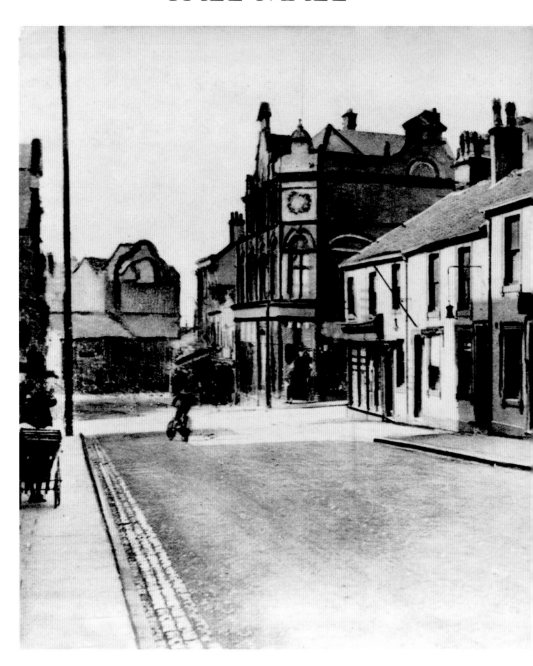

PALL MALL RUNS from Albion Street, crosses Piccadilly and on to Marsh Street – so cutting Piccadilly into two halves. There are predominantly houses on this side of the street, with the Hanley Museum and the Hanley Public Library just out of picture on the left. The large corner

building across Piccadilly was built in 1896, and further down the lower part of Pall Mall is the Theatre Royal. In the distance on Marsh Street is the YMCA building.

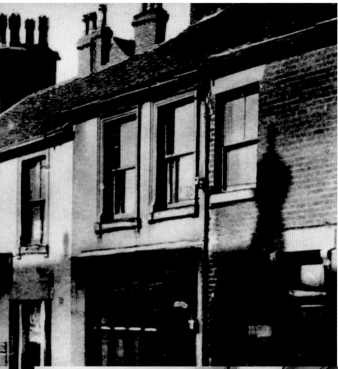

AT THE TOP of Pall Mall some of the old houses still stand proudly, defying the modern planner. Only the corner building still stands from the old picture. During the late 1990s, the Regent Theatre expanded into Pall Mall, building dressing rooms and a stage-door entrance. The Theatre Royal has now closed, and the YMCA building has given way for a modern BT telephone exchange.

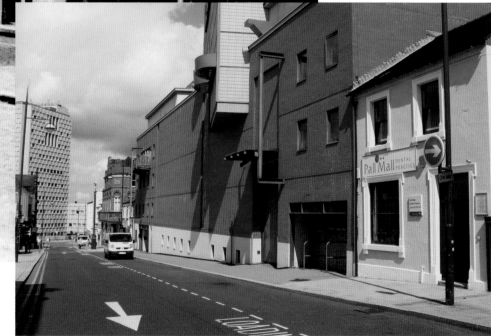

HANLEY HIGH SCHOOL

THIS HIGHER GRADE School was opened on 6 April 1893 and continued as such until 1903. Situated between Old Hall Street and Birch Terrace, it came under the Education Act of 1902 and was officially recognised as a secondary school for boys and girls. In 1924, a further change of title gave the school its most familiar name, 'Hanley High School'. The school became a boys-only school in 1938, when the girls were transferred to the Thistley Hough School for Girls. The building was vacated shortly after, in 1939, after being declared unsafe: the boys moved to Brownhills High School, then to Chell and finally, in 1953, to Bucknall.

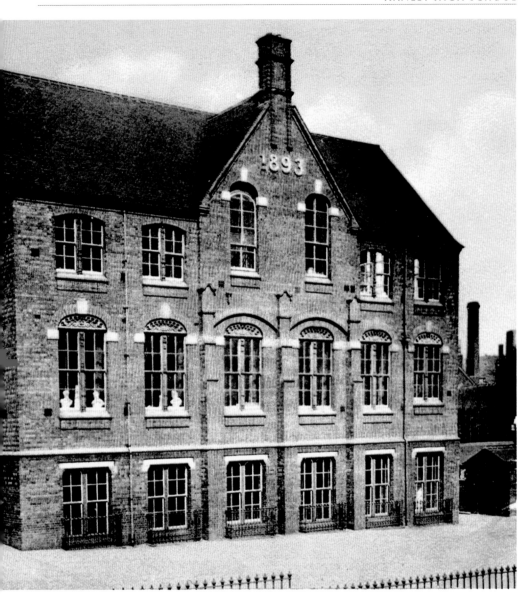

HANLEY HIGHER GRADE School was demolished before the Second World War and the site was used for commercial properties until the 1970s, when Hanley Bus Station was built. The Hanley Bus Station included many shops, a restaurant and a dance hall. The building and bus amenities were first class when new but have become 'tired' over the years. A new and more modern bus station is being built behind the photographer and a new shopping complex, cinema and large hotel will be built on this site.

Hanley High School had a reputation for producing many distinguished local businessmen. The community that was Hanley High School are still proud today under the banner of being a Hanliensian.

HARRISON AND SONS, GARTH STREET

HARRISON AND SONS (Hanley) Ltd were justifiably proud of their fleet of delivery vehicles when the photograph below was taken in around 1930. The land to the left, up Garth Street

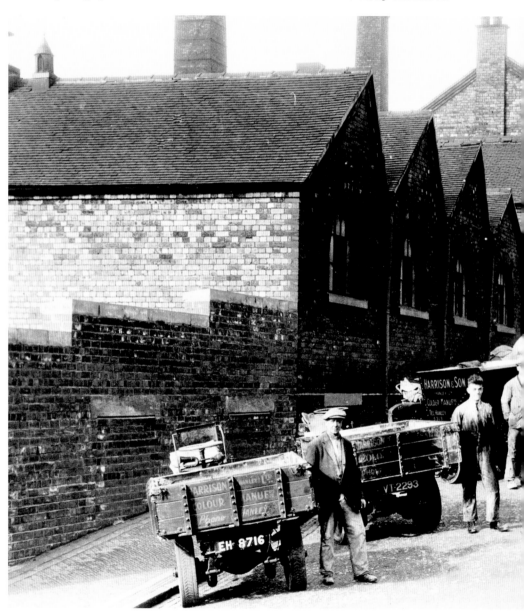

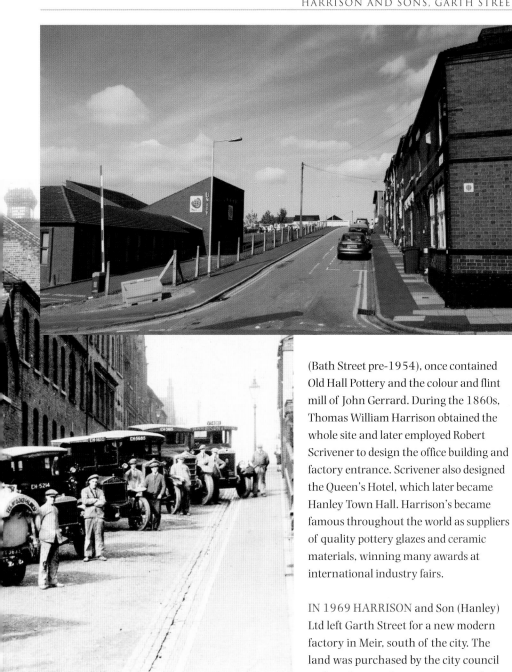

(Bath Street pre-1954), once contained Old Hall Pottery and the colour and flint mill of John Gerrard. During the 1860s, Thomas William Harrison obtained the whole site and later employed Robert Scrivener to design the office building and factory entrance. Scrivener also designed the Queen's Hotel, which later became Hanley Town Hall. Harrison's became famous throughout the world as suppliers of quality pottery glazes and ceramic materials, winning many awards at international industry fairs.

IN 1969 HARRISON and Son (Hanley) Ltd left Garth Street for a new modern factory in Meir, south of the city. The land was purchased by the city council and made into a large open car park. In one corner the Potters' Union built their offices and meeting rooms. This building is now used by the Unite Union. The houses to the right of Garth Street have seen all these changes.

VICTORIA SQUARE

TRAVELLING DOWN BROAD Street and going out of Hanley towards Shelton is Victoria Square, dominated by the Jug Hotel on the left-hand corner. In 1912, this occupied all the buildings up to Cannon Street. By 1925 the Jug had changed its name to The Victoria. To the right of the picture was the home of the Shropshire and Staffordshire Royal Garrison Artillery Volunteers

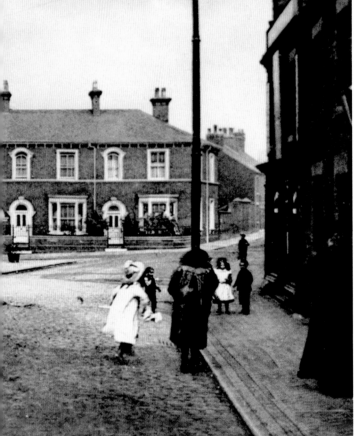

(Headquarters) 3rd and 4th Batteries, with a compliment of 421 men.

THE VICTORIA HOTEL still stands proudly in Victoria Square but is now called 'The Victoria on the Square'. The military headquarters have gone and the ground is occupied by a leading vehicle dealership, though the front of the old Drill Hall can still be seen in nearby College Road. All the buildings on the left have been demolished save the old Hanley brewery of Dix and Co. (whose chimney can be seen to the left, behind the tree).

THE POTTERY FACTORY, CAULDON PLACE

SITUATED ON THE side of the Caldon Canal between Stoke Road and what is now College Road, this pottery factory was first built in 1802 by Job Ridgway. This picture of Cauldon Pottery is

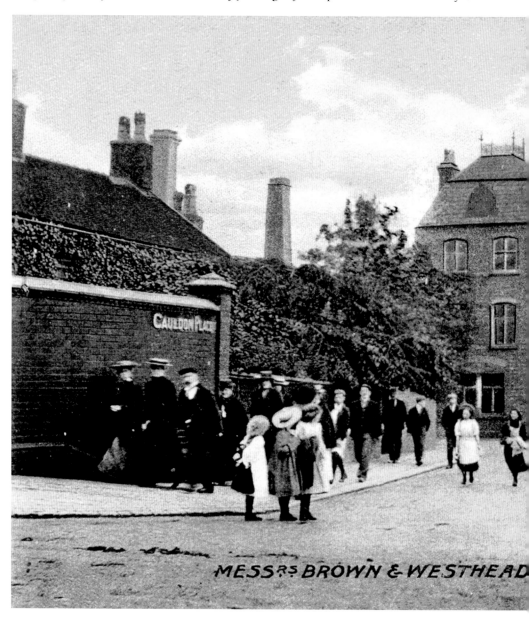

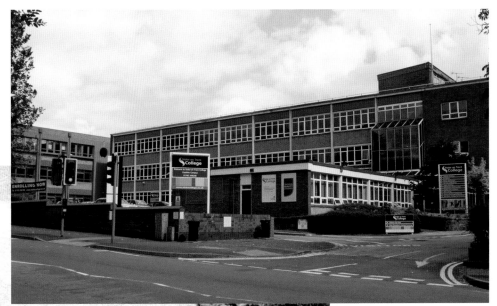

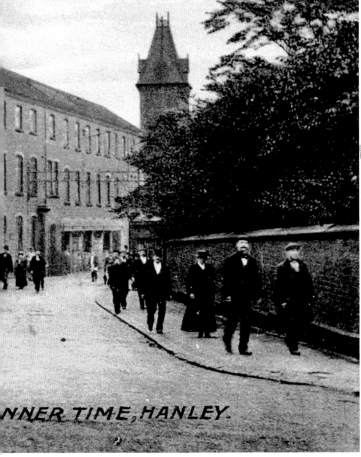

NNER TIME, HANLEY.

taken from the Stoke Road entrance as the workers go for lunch. When Job Ridgway died, his son, John, took over the pottery; it was later held by Bates & Co., then Bates & Westhead, and then, in the first part of the twentieth century, by Brown & Westhead.

STOKE-ON-TRENT College now occupies the site of Job Ridgway's Cauldon Pottery. The popular Cauldon Campus teaches a range of subjects from language, teacher training and business management to skilled trade training (such as all types of building apprenticeships). Being close to Hanley Park makes this college a popular place of learning.

BETHESDA CHAPEL,
ALBION STREET

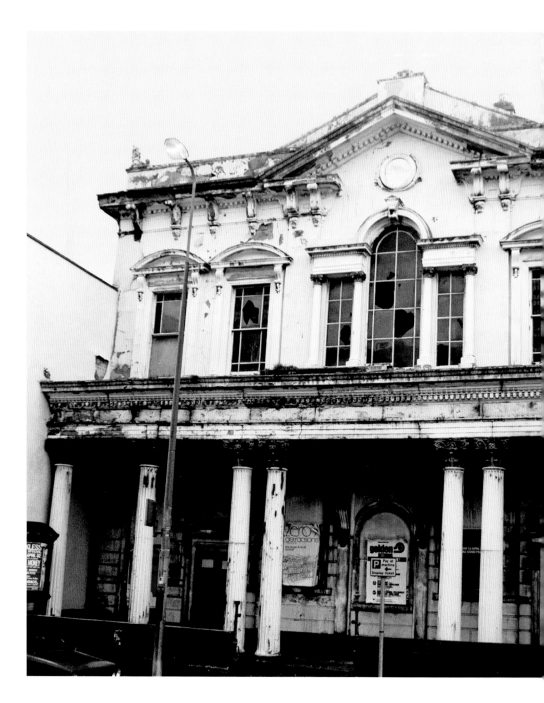

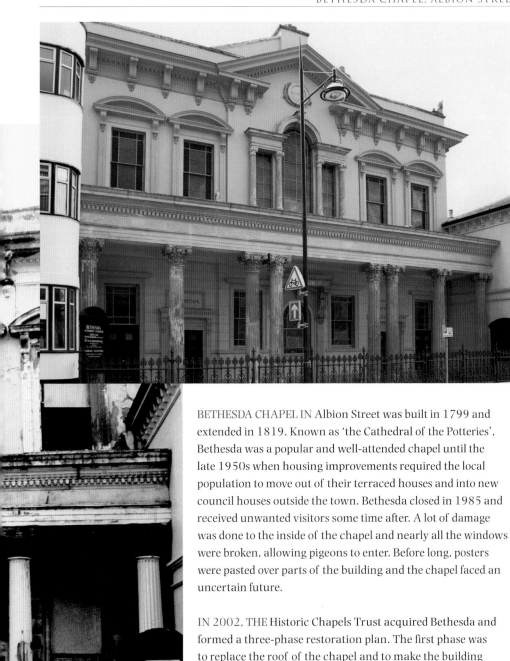

BETHESDA CHAPEL IN Albion Street was built in 1799 and extended in 1819. Known as 'the Cathedral of the Potteries', Bethesda was a popular and well-attended chapel until the late 1950s when housing improvements required the local population to move out of their terraced houses and into new council houses outside the town. Bethesda closed in 1985 and received unwanted visitors some time after. A lot of damage was done to the inside of the chapel and nearly all the windows were broken, allowing pigeons to enter. Before long, posters were pasted over parts of the building and the chapel faced an uncertain future.

IN 2002, THE Historic Chapels Trust acquired Bethesda and formed a three-phase restoration plan. The first phase was to replace the roof of the chapel and to make the building secure from pigeons and unwanted visitors. Part of phase one was to repair the frontage and replicate the colour used when the Methodist Conference was held there in 1860. When the Historic Chapels Trust and the local Friends of Bethesda opened the building for a 'completion of phase one' celebration in 2007, over 1,000 people came to see what had been done.

THE BOAT HOUSE, HANLEY PARK

THE BOAT HOUSE on the side of Hanley Park lake was the place to go for your ticket to hire a boat, or a permit to fish the lake – it even sold ice cream in the 1950s. Boating on the lake was a very popular weekend pastime for young couples, and began soon after the park opened in 1897. The keen eyes

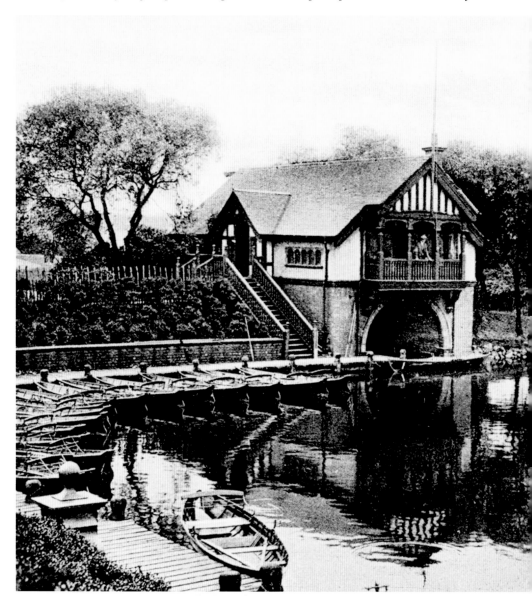

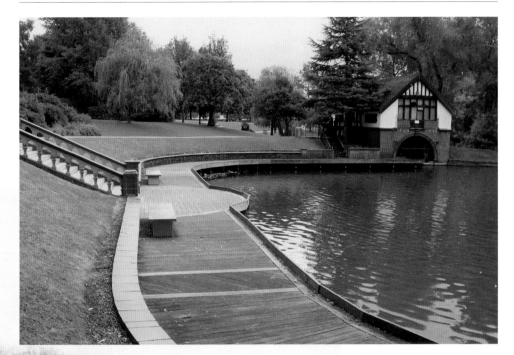

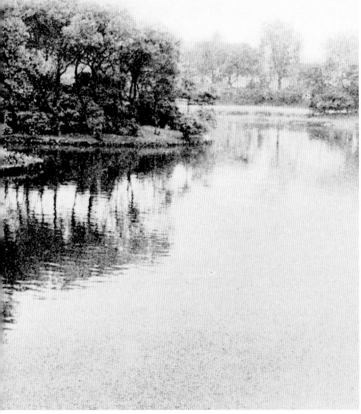

of the boatkeeper were kept on all who hired the rowing boats – and woe betides anyone who spoiled the day for other users! Hanley Park Lake was also a wonderful place for children to go and feed the ducks.

THE BOAT HOUSE is now closed and has not had any boats to hire for many years. Even the boatkeeper's wooden veranda is missing. Anglers can often be seen fishing in the five-acre lake, though, and children still feed the many lovely ducks. Hanley Park lake has always been a haven for wildlife, and any future plans can only improve its use.

THE BANDSTAND AND
PAVILION, HANLEY PARK

A PERFECT SUMMER
Sunday afternoon
for the people of the
Potteries would be to
come to Hanley Park
and listen to a band and
enjoy a cup of tea in the
pavilion. The park was
opened on 20 June 1897
and occupies about 63
acres. The pavilion was
completed in 1896 and
designed by Dan Gibson,
and the bandstand was
a gift to the park by Mr
George Howson, a local
potter. Most weekends
in the summer a local
band would entertain
the park visitors.

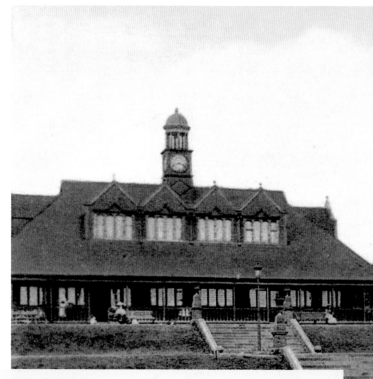

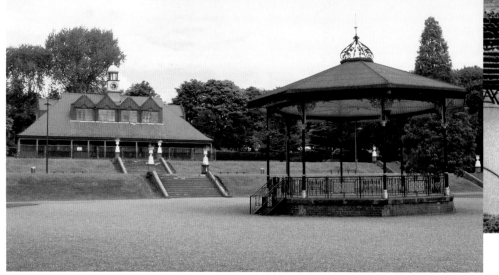

THE BANDSTAND AND PAVILION, HANLEY PARK

THERE ARE NO permanent seats around Hanley Park bandstand today because bands hardly ever play there. The pavilion is all boarded up and fenced off so cannot be used. Though the park is clean and tidy, there is little evidence of how popular this park used to be fifty or more years ago. The city council have plans to bring the park back to its former glory (and into the twenty-first century) with the help of the newly formed Friends of Hanley Park.

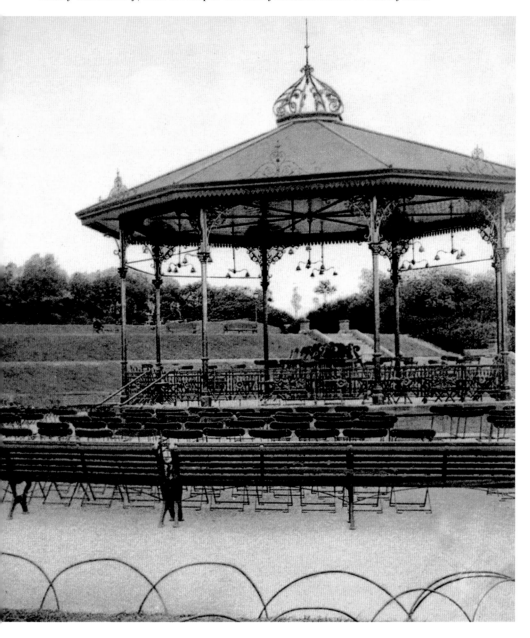

ETRURIA PARK

ETRURIA PARK IS the smallest of Hanley's parks and built on land close to the main road between Hanley and Newcastle-under-Lyme. The Etruria pottery of Josiah Wedgwood can be seen in the background of this picture and lies across the road from the park. When the park opened on 29 September 1904, a most prominent feature was this magnificent water fountain, given by Mr Jesse Shirley and decorated with plaques made by Wedgwood. The front of the water fountain had a marble water bowl, plus a thermometer and barometer in a rear panel.

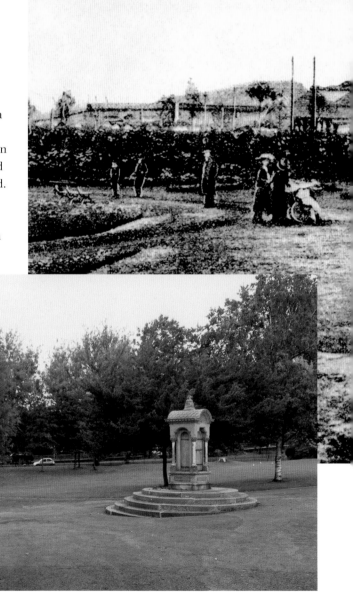

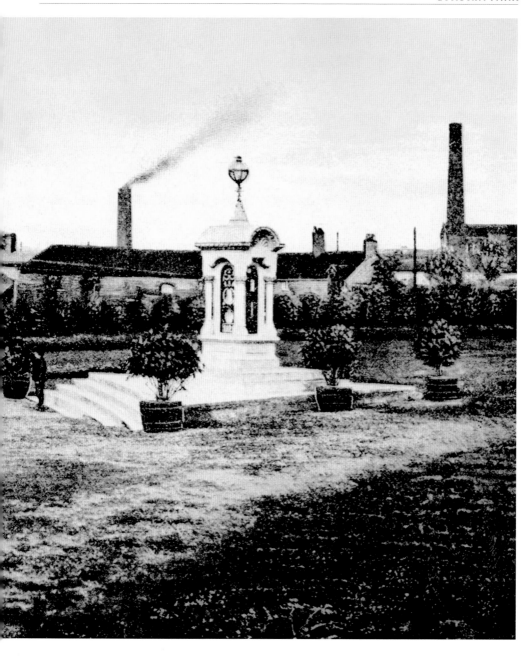

THE WATER FOUNTAIN still stands in Etruria Park but over the years has had the attention of unwanted visitors. The Wedgwood panels were removed by the council and placed in storage, and the square plinth was reformed. The rest of the park is much as it was and is well used by local families. Josiah Wedgwood's Etruria Pottery moved to Barlaston in about 1950. One feature today is a bowling green and a basketball court was also recently added. With a school close by, the park is often used for the summer sports day.

BIRCHES HEAD ROAD,
JUST OUTSIDE HANLEY

KNOWN LOCALLY AS Birches Head Lane, this old lane was the main walkway for the monks of Hulton Abbey to what was Hanley Upper Green and on to Stoke or Burslem. When the photograph below was taken, in around 1912, this lane was just as important as a link road as it was in the thirteenth century. This picture shows the top of Birches Head Road, with

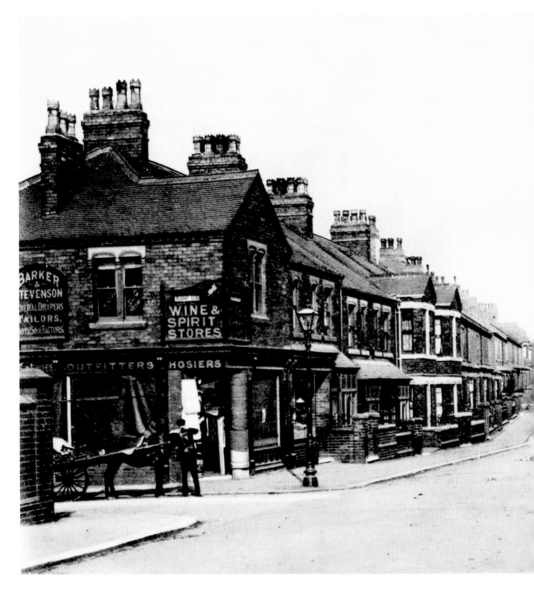

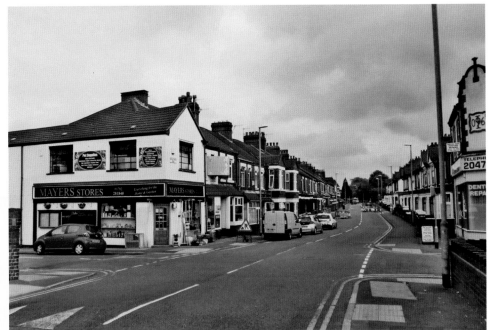

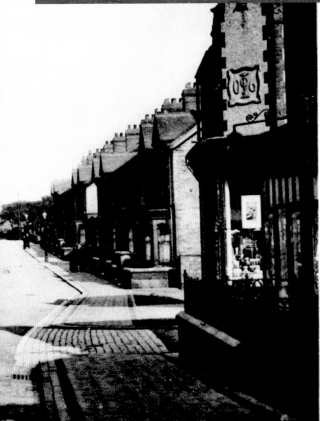

beautiful Victorian terraced houses on each side and a corner shop owned by Barker & Stevenson. The road leads off the picture through farmland and on over the Caldon Canal and River Trent to the main Stoke to Leek road.

THE MOST OBVIOUS changes along this part of Birches Head Road are the modern vehicles parked outside the houses and that the corner shop has changed hands. The shop was acquired in the 1940s by the Mayer family, who still help to run the shop today. In the old picture the Victorian houses stopped at the end of the picture and the lane continued on to farmland, whereas today's lane leads to modern housing estates, a large school complex and the Bridge Centre before going on to Leek Road.

ST MATTHEW'S CHURCH, BIRCHES HEAD

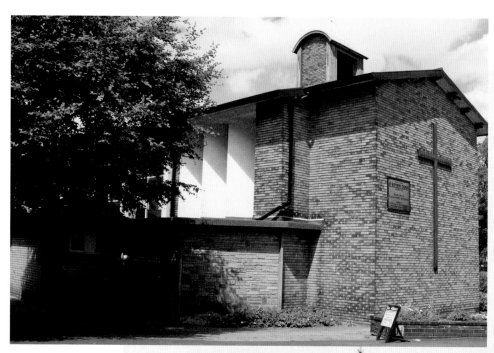

ST MATTHEW'S CHURCH in Birches Head was loved by local people and known affectionately as 'the tin church'. This was because this small church was built using a wooden frame with corrugated tin sheets fitted to the outside. The inside had wooden panels on the walls

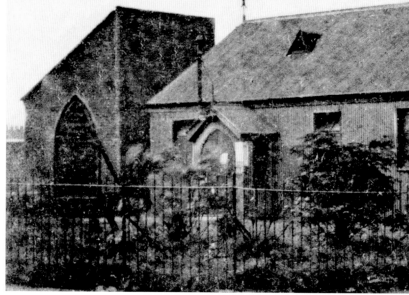

and was heated by a stove pot. Always the centre of the community, the church had very successful Boy Scout and Girl Guide troops which ran from the church's community hall in Addison Street.

THIS LOVELY BRICK church replaced the old church during the 1960s and celebrated 100 years of a church on this site in 1999. Today St Matthew's is a building with all modern amenities and boasts a strong congregation. The church holds two fairs during the year, has coffee mornings and many other social events, such as dinners and buffets.

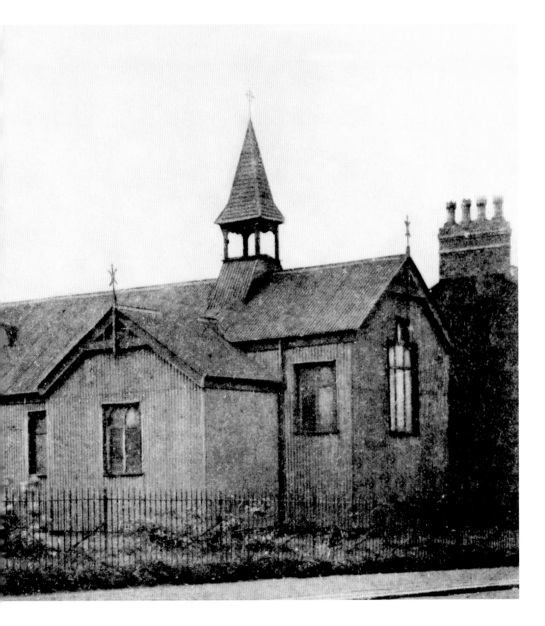

PROVIDENCE CHAPEL

LEAVING HANLEY BY High Street (Town Road today) and passing Hanley Deep Pit, Providence Chapel sits in the middle of the road junction to Northwood, Birches Head and Sneyd Green. Built in 1839 on land donated by the Duchy of Lancaster, the chapel was modernised in 1924.

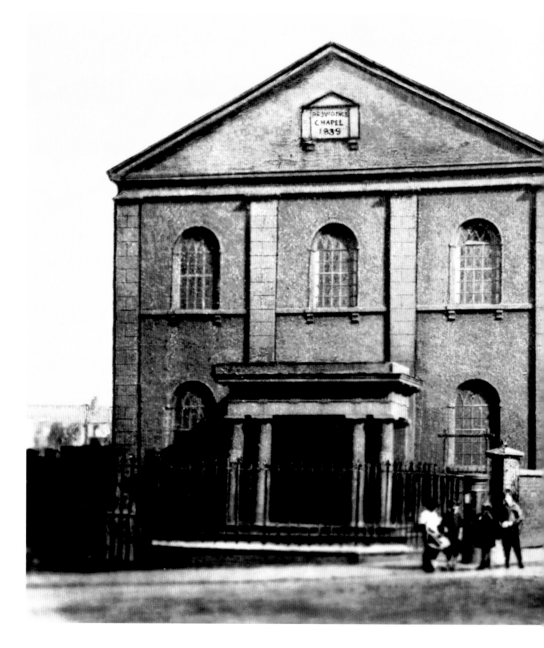

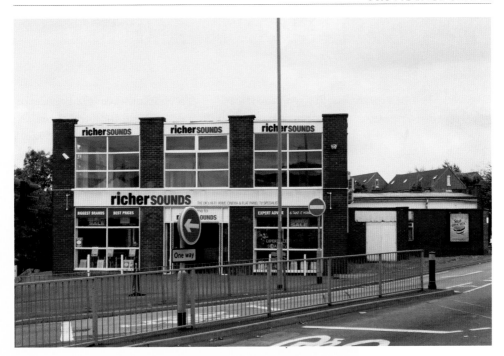

Inside, the chapel is a typical galleried Methodist Chapel while on the walls are written religious texts.

FALLING CONGREGATIONS IN the late 1960s sadly caused the chapel to close and be demolished. The land was sold and a large commercial outlet built in its place. Originally used as a second hand car outlet, the building has gone through various changes to make it what it is today.

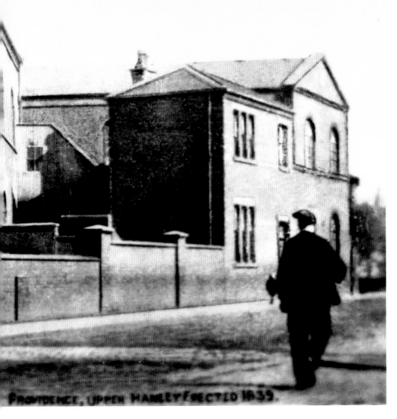

PROVIDENCE, UPPER HANLEY ERECTED 1839.

CHELL STREET

THE PREFAB IN the background of this picture was one of nine built early in the 1940s. Some were occupied by servicemen returning from the Second World War. These two-bedroom prefabricated concrete bungalows were very well fitted out: they contained a gas cooker, a gas fridge, an airing cupboard, had central heating, fitted wardrobes, a bathroom and an inside toilet. They had a nice front garden and a sizeable back garden, large enough for the occupier to have a vegetable patch. This picture shows the author and his cousin, Gill Goodall, helping out in the back garden shortly after the prefabs were built.

ALTHOUGH ONLY MEANT as temporary homes, the prefabs in Chell Street were occupied for over twenty-five years. Where the prefabs stood is now the main entrance to the car park for Hanley Forest Park. Built mostly on land once occupied by Hanley Deep Pit, this lovely park has a large lake and a skateboarding arena. The two large colliery spoil mounds have been transformed into high vantage points where the visitor who climbs to the top can look over much of Stoke-on-Trent.

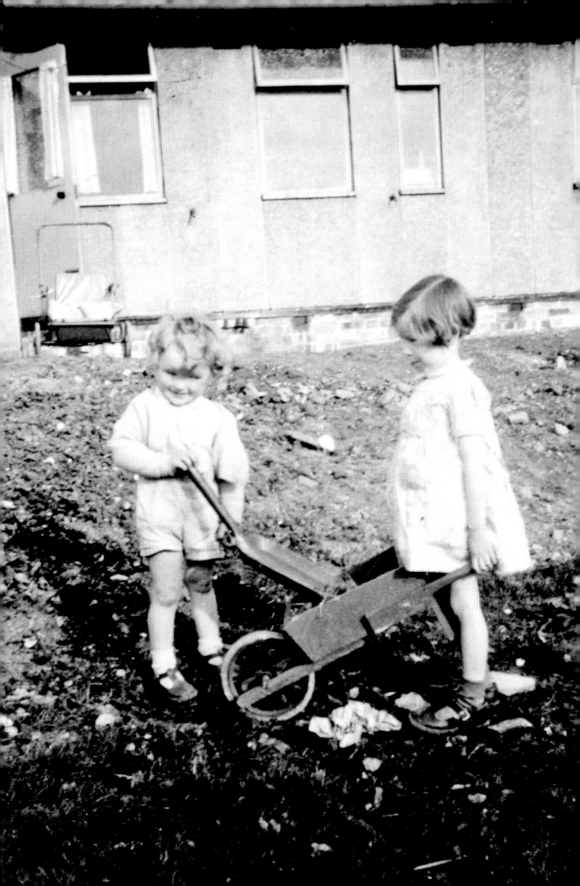

HOWARD PLACE, SHELTON

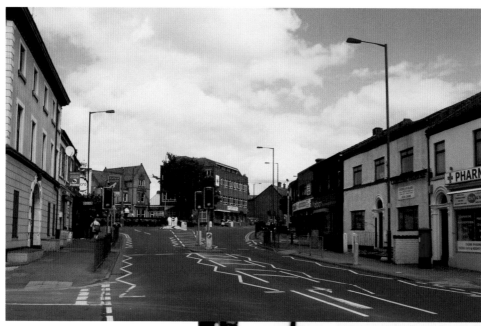

HOWARD PLACE IS about halfway between Hanley and Stoke, and during Victorian times it boasted many important residences. Mr R.G. Howson, potter, lived in the large house known as The Elms, which can be seen in the distance on the left. This view shows the road junction from Stoke leading to Hanley on the right and Etruria on the left. Elijah Fenton, the seventeenth-century writer, was born in Shelton Old Hall, which was situated beside the Hanley road above this junction.

TODAY THIS BUSY road junction still contains many houses built over 100 years ago. The Elms is now a popular restaurant and the

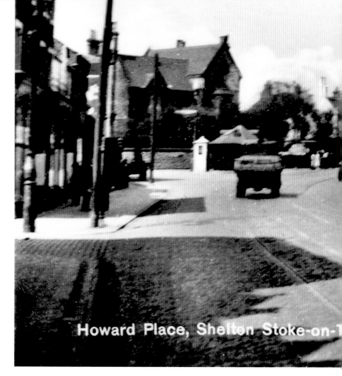

Howard Place, Shelton Stoke-on-T

large building in the centre of the picture is the Snow Hill Building, an annex of Stoke-on-Trent College. As you pass the large house on the left of the picture, take time to look at the keystone above the arched doorway. The keystone is the face of the Green Man from folklore though this one is painted blue with white eyes.

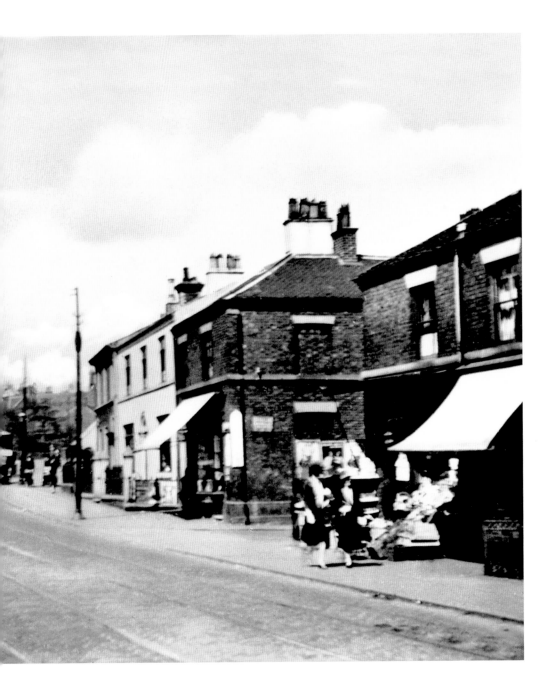

JOSIAH WEDGWOOD LTD, ETRURIA

IT WAS WITH the words *Artes Etruriae Renascuntur* that Josiah Wedgwood christened his new Etruria works when it opened in 1769: 'The arts of Etruria are reborn'. Josiah purchased land previously known as The Ridge House Estate, beautiful woodland and pasture fields on the outskirts of Hanley. On this land he built his new pottery and a village to accommodate his workers. He was inspired by Etruscan relics, introduced to the country by Sir William Hamilton,

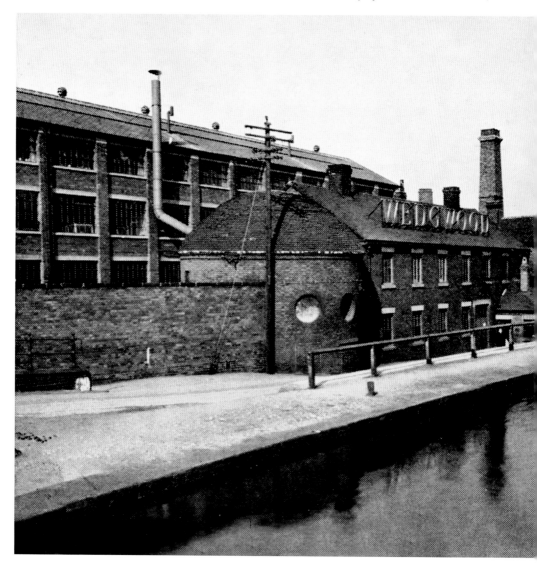

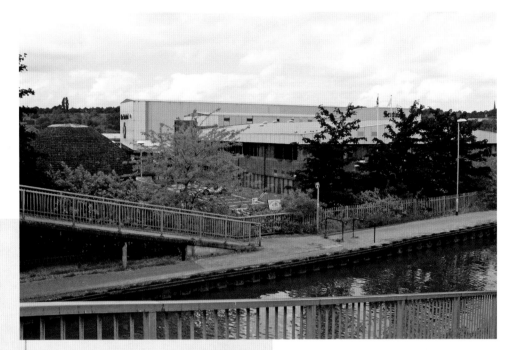

and so called the area 'Etruria'. The close proximity to the canal meant that his wares could be safely transported to Liverpool – and there, by ship, throughout the world. This factory was finally demolished in 1966, leaving only the Round House, which is just left of centre.

THE OLD WEDGWOOD pottery site was part of the very successful Stoke-on-Trent Garden Festival, the second in a National Garden scheme and opened by the Queen in 1986. When the 180-acre garden festival ended, the site was converted into a large retail and entertainment site. The local *Sentinel* newspaper business moved here from Hanley and, in 1987, Princess Margaret opened their new offices. The Round House building was retained after the pottery was demolished and used in the festival. This building can still be visited today and can be seen on the left of this picture.

Other titles published by The History Press

Staffordshire Women
PAM INDER & MARION ALDIS

The world of the nineteenth-century woman was extremely narrow. Quiet, uncomplaining, and of delicate constitution, she spent her days at home with her family. History has not remembered these nine women. They came from a variety of backgrounds but the thing that links them is that they were financially able. They survived abusive husbands, bankruptcy, impecunious relatives and heart-breaking personal tragedies to achieve surprising levels of success, and every one of them was a Staffordshire woman.

978 0 7524 4881 7

Steam Around Stafford
MIKE HITCHES

A pictorial history of the railways around Stafford, including the Grand Junction Railway, the Trent Valley Railway, and the branches of the Great Northern Railway. Illustrated with over 200 black and white photographs, plans and adverts *Steam Around Stafford* is an invaluable guide to a intriguing topic. Railway author Mike Hitches was born in the Midlands, and his informative captions will make pleasurable reading for rail enthusiasts everywhere.

978 0 7524 5113 8

South Staffordshire Ironmasters
RAY SHILL

Several generations have now passed since iron making and working was an important trade in the Black Country. Such is the nature of the trade that supply and demand created periods of expansion and then through over production an inevitable slump. Political factors also had influence. Wars created increased demand for iron for ordnance. When the battles were over and the wars won or lost, the bigger losers were the ironmasters and their workforce.

978 0 7524 4831 2

Staffordshire Murders
ALAN HAYHURST

Staffordshire Murders brings together murderous tales that shocked not only the county but made headline news throughout the nation. They include the poisonous Dr Palmer, murder on the canal, the body in the gasometer, the chauffeur's revenge, and much more. Alan Hayhurst's well-illustrated and enthralling text will appeal to all who are interested in the shady side of Staffordshire's history.

978 0 7509 4706 0

Visit our website and discover thousands of other History Press books.
www.thehistorypress.co.uk

The History Press